IMAGES
of America

ELLICOTT CITY

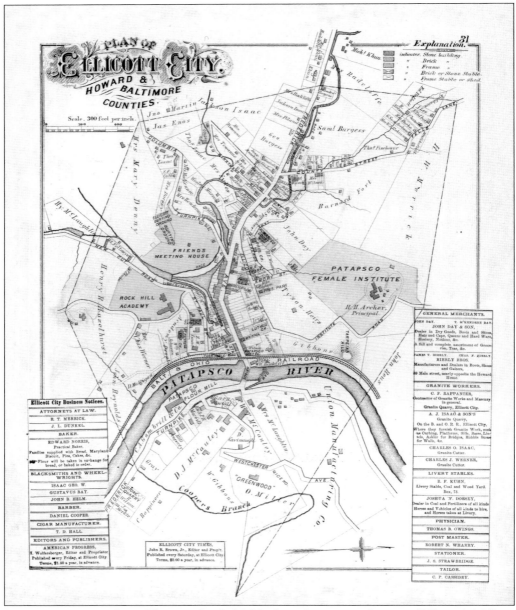

PLAN OF ELLICOTT CITY. This map by G. M. Hopkins shows an early view of Ellicott's Mills in 1878. (Courtesy of the Howard County Historical Society.)

ON THE COVER: Rodey's News Depot, shown here *c.* 1900, was located at 8048 Main Street, home today to the Forget Me Not Factory. (Courtesy of the Howard County Historical Society.)

IMAGES
of America

ELLICOTT CITY

Marsha Wight Wise

ARCADIA
PUBLISHING

Copyright © 2006 by Marsha Wight Wise
ISBN 0-7385-4249-0

Published by Arcadia Publishing
Charleston SC, Chicago IL, Portsmouth NH, San Francisco CA

Printed in the United States of America

Library of Congress Catalog Card Number: 2005938870

For all general information contact Arcadia Publishing at:
Telephone 843-853-2070
Fax 843-853-0044
E-mail sales@arcadiapublishing.com
For customer service and orders:
Toll-Free 1-888-313-2665

Visit us on the Internet at www.arcadiapublishing.com

To the Four Wise Men: John, Matthew, Jared, and Jason.
You are all my precious gifts.

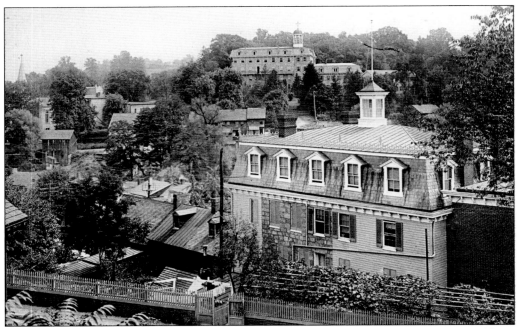

ELLICOTT CITY SKYLINE. This view from high atop Court House Lane shows the rear of buildings on Main Street. Rock Hill College can be seen in the distance. (Courtesy of the Enoch Pratt Free Library.)

CONTENTS

ACKNOWLEDGMENTS

My deepest gratitude goes to my husband, John, and our sons, Matthew, Jared, and Jason. Thank you for giving me time off from my duties as mom to write this book.

I would like to thank the follow individuals: Michael Walczak, executive director of the Howard County Historical Society, for his patience, invaluable time, and always going above and beyond the call of duty to help me; Constance Colbert Wehland, president of the Howard County Historical Society for all of her assistance in getting this book off of the ground; Gladys Wahlhaupter, volunteer at the Howard County Historical Society, for always finding space for me; Jeff Korman, manager of the Maryland Department of the Enoch Pratt Free Library, for never growing weary of Arcadia authors; Bill Bates, author, for taking me under his wing; Paul E. Hill, for taking a trip down Memory Lane (Main Street) with me. Last, but not least, I want to thank Lauren Bobier, publisher at Arcadia Publishing, for all of her energy and inspiration and for always making me feel like I was the only author she had in production.

I would also like to thank the generous individuals who opened their homes and shared their personal family histories, photographs, and collections with me: William Hollifield, Jim Hooper, Fred Dorsey, Alice Fort, and Jacque and Gladys Tittsworth.

To the best of my ability, I have attempted to ensure accuracy given the antiquated and often obscure nature of the subject matter and materials.

REFERENCES

Cramm, Joetta M. *Historic Ellicott City: A Walking Tour.* Woodbine, MD: K and D Limited, Inc., 1996.

———. *Howard County: A Pictorial History.* Virginia Beach: The Donning Company, 1987.

Holland, Celia M. *Old Homes and Families of Howard County, Maryland.* Ellicott City, MD: Privately printed, 1987.

Holland, Charlotte T., James C. Holland, and Janet P. Kusterer. *Ellicott City, Maryland Mill Town, U.S.A.* Ellicott City, MD: Historic Ellicott City, Inc., 2003.

Howard County Historic Sites Survey. Compiled by the Department of Planning and Zoning and the Maryland Historic Trust. 1970 to present.

Peirce, James Walter. *A Guide to Patapsco Valley Mill Sites: Our Valley's Contribution to Maryland's Industrial Revolution.* Bloomington, IN: AuthorHouse Inc., 2004.

Profiles of Faith: Histories of Religious Communities of Howard County. Ellicott City, MD: Sesquicentennial Committee of Howard County, 1999.

Shipley, B. H., and William F. Klingaman. *Remembrances of Passing Days: A History of Ellicott City and Its Fire Department.* Merceline, MO: Walsworth Publishing Company, 1997.

Travers, Paul J. *The Patapsco: Baltimore's River of History.* Centreville, MD: Tidewater Publishers, 1990.

INTRODUCTION

As you turn the pages of this book, Ellicott City's past does not seem that long ago. You will recognize many buildings and locales that may be familiar to you. Ellicott City has done a remarkable job of maintaining its old charm. In no way is this book intended to be an all-inclusive account of Ellicott City. Rather it is a photographic sampling of many of the places and people who have helped shape its past, present, and future. How I determined which subjects and people to be included in this book was a simple process—I let the photographs that I collected guide me.

There are a few changes through time to keep in mind as you read this book. First, Howard County was not always a county unto itself. It was designated the Howard District for John Eager Howard, the fifth governor of Maryland, in 1839. Howard County became an official independent jurisdiction in 1851, the 21st of Maryland's 23 counties, with the county seat at Ellicott's Mills. Second, Ellicott City has not always been named such. When found by the Ellicott brothers, the town was called Ellicott's Mills. In 1867, a city charter was secured for Ellicott's Mills and the name was changed to Ellicott City. Thirdly, Ellicott City proper is located in Howard County, but parts of it are now located in Baltimore County.

In the first chapter, "The Ellicott Brothers," you will meet the town's namesakes—Joseph, Andrew, and John Ellicott—and their descendants. The three Quaker brothers from Bucks County, Pennsylvania, chose this picturesque wilderness to establish a flour mill in 1772, four years before the Declaration of Independence was signed. The brothers helped revolutionize farming in Maryland by persuading farmers to plant wheat instead of tobacco and by introducing fertilizer to revitalize the depleted soil.

The second chapter, "The Mills," will introduce you to not only the Ellicotts' flour mills, but the many mills that subsequently dotted the banks of the Patapsco River: Gray's Cotton Mill, Oella Mill, Thistle Mill, Burgess Grist Mill, Alberton-Daniels Mill, and the Orange Grove Flour Mill.

The third chapter, "The Schools," will have you soon realizing the important role that Ellicott City played in higher education. Quite a few colleges called Ellicott City home: St. Charles College, Patapsco Female Institute, and Rock Hill College. Also covered in this chapter are the lower schools of Ellicott City.

The fourth chapter, "The Churches," shows how religiously diverse Ellicott City is. The churches covered here are Emory Methodist Episcopal Church, St. John's Episcopal Church, First Presbyterian Church, St. Paul's Catholic Church, St. Peter's Episcopal Church, and First Evangelical Lutheran Church.

The fifth chapter, "The Homes," will give you a glimpse of the early homes of Ellicott City residents. Some have stood the test of time and still stand, either as private residences or institutions. Some fell into the path of progress and were razed. A few remnants remain—a gatepost here, a stone fence there. Included in this chapter are Woodlawn Hall, Angelo Cottage, Mount Ida, the Lindens, Doughoregan Manor, Folly Quarter, Burleigh Manor, Oak Lawn, Font Hill, Patapsco, Spring Hill, Kraft-Slack House, Elk Ridge Farm, Macgill House, Broxton, and Temora. And what is an old house without a ghost story or two?

The sixth chapter, "The Merchants," will have you meeting the many merchants of Ellicott City. They were vital components of daily life, as they provide the necessities to live. Whether it was a grocer, an undertaker, a banker, a tavern keeper, an artist, or a pharmacist, a town could not survive and grow without them.

The seventh chapter, "The Public Servants," pays homage to the firemen and law keepers that maintained order when Ellicott City found itself thrown into chaos.

The eighth and final chapter, "Faces and Places," is made up of people and images that appealed to me in my research. Many of these stories have never been told before. I hope that you find them interesting as well.

If this book is your first foray into Ellicott City history, then I encourage you to not stop when you turn the last page. Go and explore for yourself, and you just might make a historical discovery of your own! I recommend that you start your exploration of Ellicott City by visiting the Howard County Historical Society Museum and Research Library (http://www.hchsmd.org) on Court Avenue. Take some time to visit the museum (don't forget to drop a few dollars in the jar at the door and to pick up a membership application). Before you leave, purchase a copy of a *Historic Ellicott City: A Walking Tour* by Joetta Cramm. You will find this book invaluable in your physical explorations. For the armchair history buffs, I recommend reading *Ellicott City, Maryland Mill Town, U.S.A.* by Celia M. Holland.

If you are well versed on the subject of Ellicott City's history, I hope that I cause you to pause once or twice to think, "I never knew that!" Please visit the Web site that complements this book at www.EllicottCityBook.com.

One

THE ELLICOTT BROTHERS

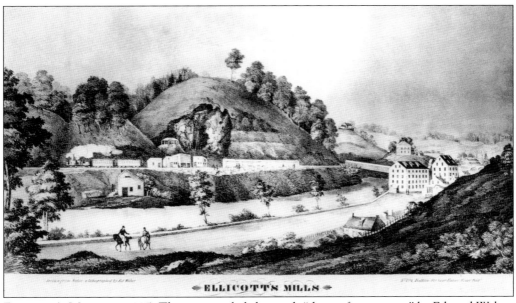

ELLICOTT'S MILLS, C. 1835. This is an early lithograph "drawn from nature" by Edward Weber. Depicted are the flour mills and homes of the Ellicotts along the Patapsco River. A locomotive and two railroad cars appear on the far banks of the river. The Baltimore and Ohio Railroad (B&O) serviced Ellicott's Mills by 1830. (Courtesy of the Howard County Historical Society.)

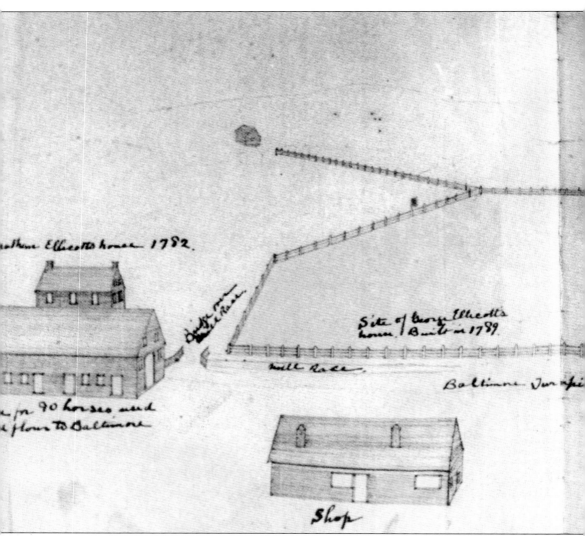

Jonathan Ellicotts house 1782.

Site of George Ellicotts house Built in 1789.

mill Race.

Baltimore Turnpike

for 90 horses used flour to Baltimore

Shop

SKETCH OF ELLICOTT'S MILLS, 1782. This is an early sketch drawn by George Ellicott in 1782 of the mills and homes of the Ellicott brothers. Jonathan Ellicott's first house can be seen to the far right, built in 1772. The flour mill, sawmill, and warehouse are seen adjacent to his home. At far left, in the rear, is the second home of Jonathan Ellicott, built in 1782. The building in front

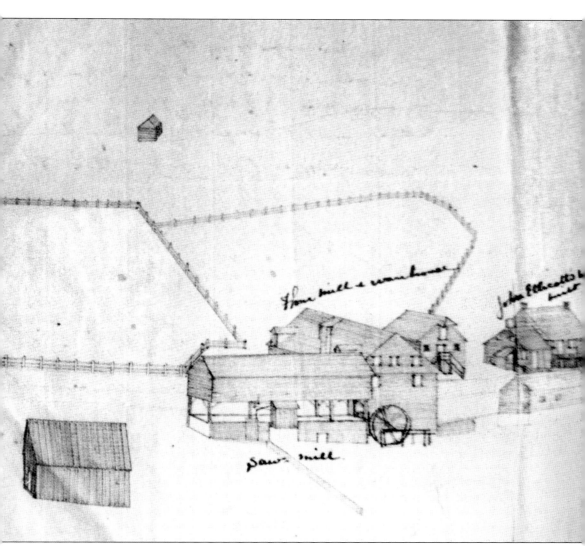

of Jonathan's home was a stable to house 90 horses used to pull wagons transporting flour to Baltimore. George Ellicott's granddaughter labeled the sketch and the location of his home, built in 1789, after the sketch was made. (Courtesy of the Howard County Historical Society.)

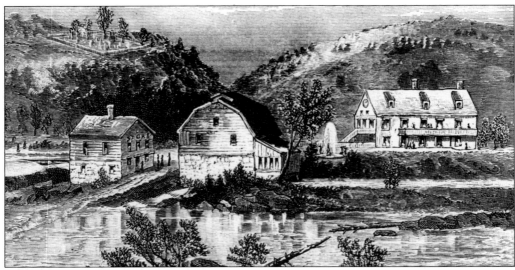

ELLICOTT'S UPPER MILL, C. 1781. In 1774, Joseph Ellicott, after receiving a substantial inheritance, established Ellicott's Upper Mill on the Patapsco River, three miles north of the original or Lower Mill. Seen here are Joseph's home, Fountainvale; the mill store; and the fountain that fed the fishpond. None of the buildings remain today. In 1974, the graves on the hill were relocated to the Ellicott Family Graveyard adjacent to the Quaker meetinghouse. (Courtesy of the Howard County Historical Society.)

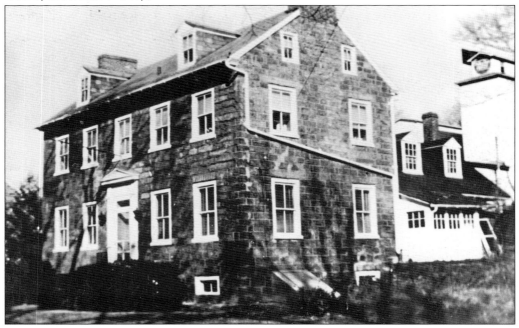

JONATHAN ELLICOTT'S HOUSE. This house was erected in 1782 by Jonathan Ellicott. Jonathan served as a captain in the American Revolution. He was the founder of the Baltimore-Frederick Turnpike (now Frederick Road) in 1797 and designer of the bridge over the Monocacy River. Jonathan and his wife raised 12 children in their home on the Patapsco River. The house was washed away in 1972 by Tropical Storm Agnes. (Courtesy of the Howard County Historical Society.)

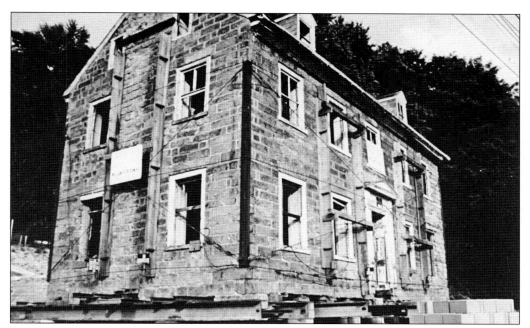

GEORGE ELLICOTT'S HOUSE. George Ellicott built his home in 1789. Besides being one of the founding Ellicotts, George was also an accomplished mathematician and amateur astronomer. George's wife Sarah Brooke Ellicott was the last Ellicott to live in Ellicott's Mills, dying in 1853 at the age of 91. The house is seen here in preparation for its move across Frederick Road. (Courtesy of the Howard County Historical Society.)

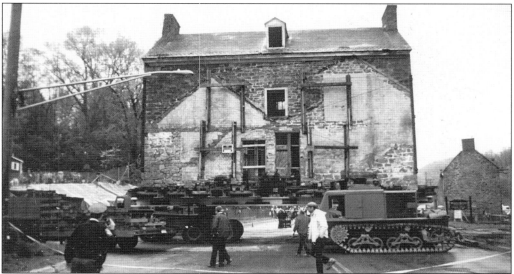

GEORGE ELLICOTT'S HOUSE BEING MOVED, 1989. After Jonathan Ellicott's house was destroyed by Tropical Storm Agnes in 1972, preservationists looked for ways to spare George Ellicott's house the same fate. In 1989, a partnership including Historic Ellicott City, Inc., Charles Wagandt's Oella Company, Judge John L. Clark, and Sen. James Clark undertook the ambitious project of moving the house across Frederick Road to higher ground. Today, after a beautiful restoration, it continues in use as office space. (Courtesy of the Howard County Historical Society.)

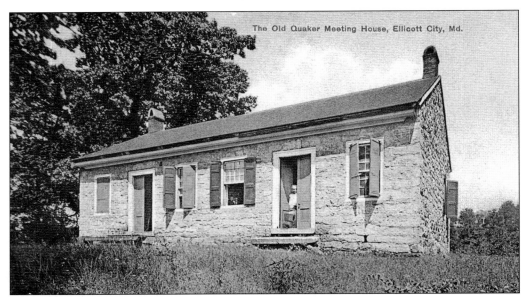

The Old Quaker Meeting House, Ellicott City, Md.

QUAKER MEETINGHOUSE, 3771 OLD COLUMBIA PIKE. In 1800, the Ellicotts built the Friends Meeting House. Previously they had traveled to Elkridge Landing twice a week for services. The meetinghouse was built from local granite. It had two entrances, one for men and one for women. By the 1830s, most of the area's Quakers had left, and the meetinghouse was abandoned. Since then, it has served as a school and a Civil War hospital; today it is a private home. (Courtesy of William Hollifield.)

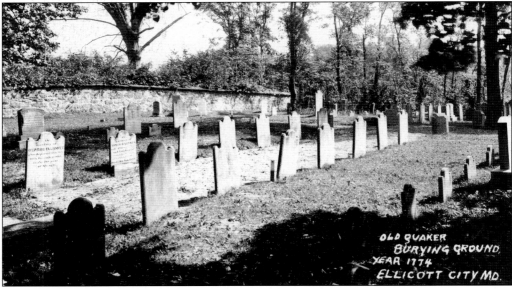

ELLICOTT FAMILY GRAVEYARD. The Ellicotts established the burial grounds around 1774. The Quaker meetinghouse was later built on adjacent land. Here the founding fathers of Ellicott City were laid to rest. Positioned against one wall of the graveyard are the headstones of the graves originally located at Joseph Ellicott's Upper Mills; however, Joseph's headstone has been lost. Today the graveyard is privately maintained and still receives the remains of Ellicott descendants. (Courtesy of the Howard County Historical Society.)

Two

THE MILLS

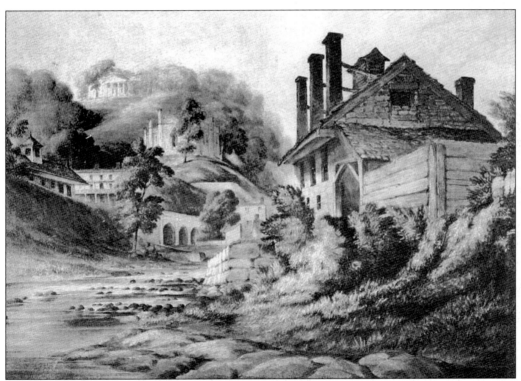

ELLICOTT'S MILLS DRAWING, C. 1840. The Ellicott brothers brought much attention to the area when they built their first mill. The full potential of the Patapsco River was realized. Many entrepreneurs followed the example and prosperity of the Ellicotts. Mills began to dot the banks of the river to the north and west of Ellicott's Mills. Depicted here are Ellicott's Mills as seen through the eyes of an artist. The original drawing is in the possession of Mr. and Mrs. F. Brennan Harrington. (Courtesy of William Hollifield.)

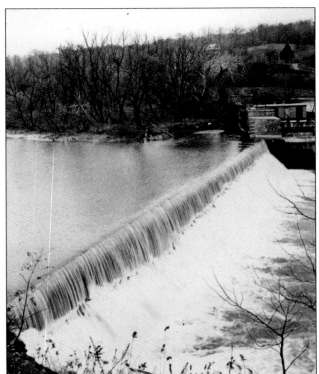

AVALON DAM. In 1761, Caleb Dorsey purchased parcels of land known as Taylor's Forest and Long Acre along the Patapsco River, where he constructed a forge and a small furnace. He also constructed a dam about a tenth of a mile upriver. The mill produced the first crowbars in the colony. In 1815, Andrew Ellicott's sons purchased the mill and started the Avalon Rolling Mill and Nail Factory. The factory was destroyed in the great flood of July 24, 1868. (Courtesy of the Enoch Pratt Free Library.)

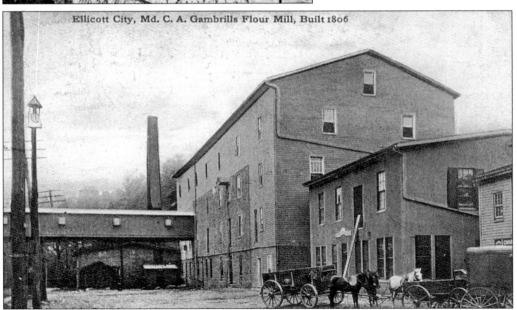

PATAPSCO FLOURING MILL. The Patapsco Flouring Mill business stayed in the Ellicott family until 1844. After several economic setbacks, the business was sold to Charles Carroll and Charles A. Gambrill. The Ellicott brothers' original 1774 mill was destroyed by fire in 1809. The 1809 mill was lost in the 1868 flood. The mill was purchased and rebuilt by Richard G. and Patrick H. Magill, nephews of Charles A. Gambrill. (Courtesy of William Hollifield.)

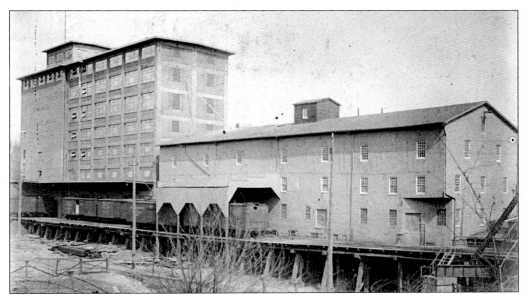

NEW PATAPSCO FLOURING MILL, SEPTEMBER 1918. In 1916, the mill was once again lost to flames. As the phoenix periodically renews itself from its own ashes, so did the Patapsco Flouring Mill, with a daily capacity of 2,400 barrels. It was the oldest flour brand name in the world. The mill has changed hands several more times and is now owned by Wilkins-Rogers, Inc., makers of Washington Quality Foods. Wilkins-Rogers continue the Ellicott brothers' tradition today by milling wheat and corn. (Courtesy of the Catonsville Room, Baltimore County Public Library.)

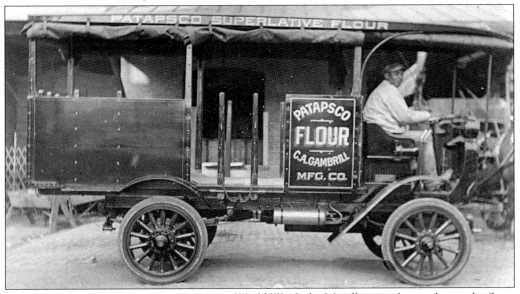

PATAPSCO FLOURING MILL TRUCK. During World War I, the Magills manufactured pancake flour. They added steam power and roller machinery to compete with Midwestern wheat processors. After the war, the Magills went bankrupt. The mill was purchased by Morris Schapiro, who changed the name to Continental Milling Company, thus ending a 150-year-old tradition. Seen here is a delivery truck still bearing Charles A. Gambrill's name. The driver is unidentified. (Courtesy of the Catonsville Room, Baltimore County Public Library.)

PATAPSCO FLOURING MILLS

ESTABLISHED 1774

106-118 Commerce Street

BALTIMORE, July 19, 1917

Subject to change without notice, we beg to offer you

Patapsco Superlative Patent, - - - $12 50

Somerset Patent - - - - -	12 35
North Point Patent, - - - - -	12 00
Bedford Patent, - - - - -	12 00
Orange Grove Patent, - - - - -	12 00
Pimlico (Graham or unbolted), - - -	12 25

SPRING WHEAT FLOUR.

Gambrill's Eagle Brand Spring Patent, - 13 00

The above prices are in Barrels, 24 lb., 12 lb. and 6 lb. sacks.
If in 98 lb. wood, prices 30 cts. per bbl. more, and if in 98 or 48 lbs. sacks, prices 20 cts. per bbl. less.

Prices above named ARE DELIVERED AT YOUR SHIPPING POINT FREE OF FREIGHT.

A Discount of Five Cents per Barrel for Cash.

PATAPSCO WHITE CORN MEAL.

WATER GROUND.

100 lb. sacks,	$4.50	per 100 lbs.
500 " lots,	4.45	"
2000 " "	4.40	"

PAT-A-CAKE

A prepared flour containing all ingredients for a perfect cake, with nothing to add but water.

Per case, (containing 12 cartons) **$1.80**

DELIVERED FREE OF FREIGHT AT YOUR SHIPPING POINT in three case lots, or in less quantities if shipped with Flour, Feed or Corn Meal.

(GRITENA Wheat Pearls)

This is an ideal breakfast food, packed in sanitary cartons. It is appetizing, nourishing and wholesome. Wheat is the most nourishing food in the world and Gritena is part of the best of the Wheat. It also makes a delicious Pudding

Per case, (containing 18 fifteen cent cartons) **$2.00**

DELIVERED FREE OF FREIGHT AT YOUR SHIPPING POINT.

SELF RISING FLOUR

Especially prepared for people who like the best BISCUITS, WAFFLES MUFFINS, GRIDDLE CAKES, Etc. Does not require any BAKING POWDER, SALT or SODA. Just add shortening and mix with water or milk and bake. It makes a failure in baking impossible.

BULL FROG (Self Rising)	-	**$12.85**
SARAH ANNE "	-	**12.50**

Put up in same packages as regular flour, and like regular flour, the prices are FOR DELIVERY AT YOUR SHIPPING POINT FREE OF FREIGHT.

PATAPSCO FLOURING MILL PRICE LIST, JULY 19, 1917. This list shows the wholesale price per barrel and sack of the mill's various products. Patapsco Flouring Mills also offered the old Southern staple of grits, elegantly named Gritena Wheat Pearls. Gritena was "an ideal breakfast food, packed in sanitary cartons. It is appetizing, nourishing and wholesome. Wheat is the most nourishing food in the world and Gritena is part of the best of the Wheat. It also makes a delicious Pudding." It retailed for 15¢ per carton. (Courtesy of William Hollifield.)

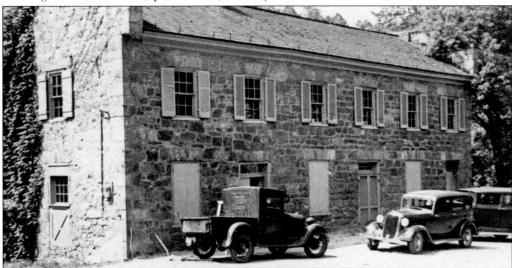

GRAY'S COTTON MILL STORE, C. 1936. This is one of two buildings still standing at Gray's Cotton Mill. This building, built around 1813, served as the mill's general store for its workers until 1888, when the mill closed. It later served as a school. Today it is divided into three residential units located at 169 Frederick Road. (Courtesy of the Howard County Historical Society.)

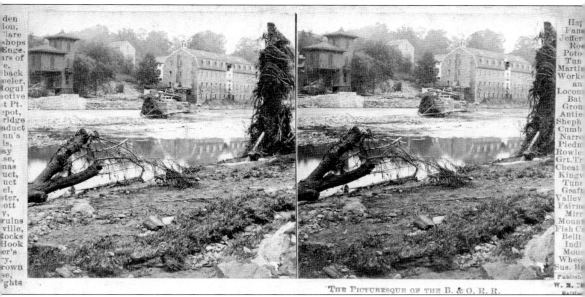

GRAY'S COTTON MILL AFTER THE FLOOD OF 1868, STEREOSCOPIC VIEW. In 1794, Peter Mendenhal purchased land from the Ellicott brothers to build a mill, with the stipulation that the mill produce anything except ground grain. Mendenhal owned his paper company for only three years before it was purchased by John Hagerty. In 1813, Edward Gray purchased the mill and converted it to produce cotton yarn and various kinds of cloth. By 1820, he had 115 employees: 40 men and 75 children. Gray built his home on the opposite bank of the river (see page 64), with a wooden bridge connecting it to the mill. In 1888, after Gray's death, his daughter Martha closed the mill. Pictured here is a stereograph of the damage done by the flood of 1868. Stereoscopes were the precursor to today's View Masters. Two photographs were taken about two-and-a-half inches apart. When viewed in a special viewer, the image appeared three-dimensional. This stereoscope was published by W. M. Chase of Baltimore as part of "The Picturesque of the B. & O. R. R." series. Listed on the outer edges are the names of other images in the set. (Courtesy of William Hollifield.)

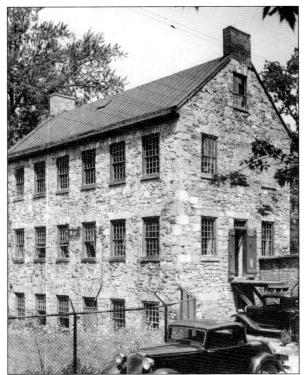

W. J. Dickey and Sons, Oella Mill, Built in 1918. In 1808, the Ellicotts sold land to the Union Manufacturing Company for the purpose of building a cotton mill. In 1887, William J. Dickey purchased the mill and renamed it. Dickey produced cotton and, later, wool goods. In 1918, the original buildings were destroyed in a fire. The building seen in this photograph was built after the fire but later razed in an expansion of the mill. (Courtesy of the Enoch Pratt Free Library.)

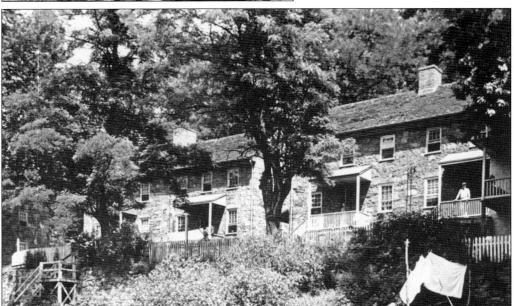

Oella Mill Houses, c. 1936. In 1811, the company developed the mill town of Oella for its workers. There are two theories on how the town received its name. One is that it was named after the first woman to have spun cotton in America. The other story is that it is an old Indian name for the area. The first homes were built of stone before the War of 1812. (Courtesy of the Howard County Historical Society.)

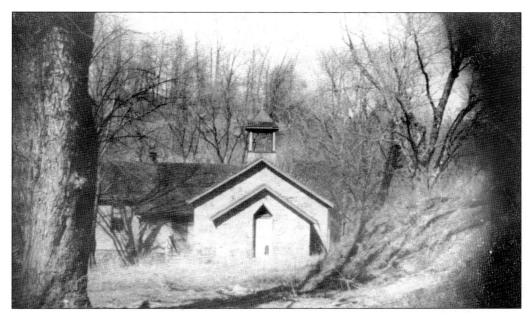

OELLA SCHOOLHOUSE, BUILT IN 1873. The school was located on the corner of Oella Avenue and Race Road. It was a three-room stone structure holding grades one through eight and heated by a potbellied stove. In 1926, the school was closed; it and other mill schools at Gray's and Thistle were consolidated into the now-defunct Westchester Annex School. (Courtesy of the Enoch Pratt Free Library.)

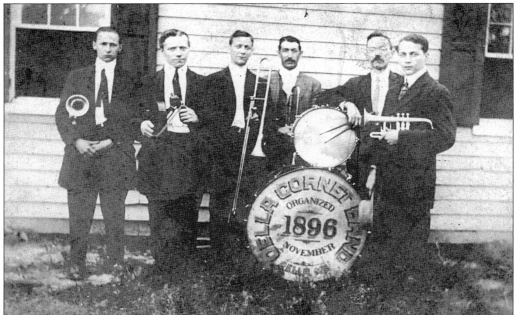

OELLA CORNET BAND. The band, according to the drum, was founded in November 1896. Typical of most mill company towns, Oella had its own band, baseball team, and police department. The Dickey Mill was in operation until 1972, when it shut its doors for good. The old mill is currently being developed into luxury condominiums. (Courtesy of the Howard County Historical Society.)

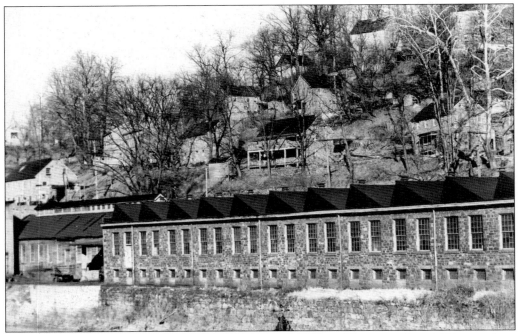

THISTLE COTTON MILL, C. 1936. In 1837, George and William Morris purchased 100 acres from John Ellicott to build a dam, millrace, and cotton mill. Thistle Cotton Mill was located on the opposite bank from Ellicott's Mill. The mill produced silk yarn, cotton thread, and cotton prints. By 1900, the mill was producing only silk. Seen in this photograph are the old mill and the town of Ilchester perched on the hill. (Courtesy of the Enoch Pratt Free Library.)

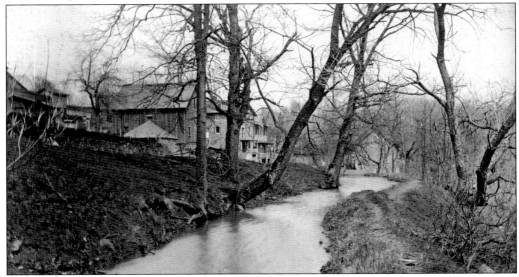

ILCHESTER COTTAGES AND MILLRACE, NOVEMBER 30, 1899. Thistle Cotton Mill workers' homes can be seen to the left, along the millrace. The company rented out the houses at a discount, allowing the mill owners to pay the workers lower salaries. The millrace, with its dam and 15-foot fall, can still be seen today running along River Road in Baltimore County. (Courtesy of the Enoch Pratt Free Library.)

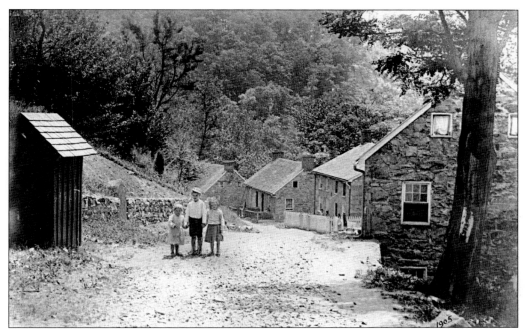

CHILDREN OF ILCHESTER, 1905. Ilchester was named after a town in Scotland, home of the founders of Ilchester. The Morris brothers designed the town to resemble Scottish mill villages with the placement of the cottages in rows on the hill. It was common for mills to employ hundreds of workers. Often these workers were young children. Girls were especially preferred. (Courtesy of the Catonsville Room, Baltimore County Public Library.)

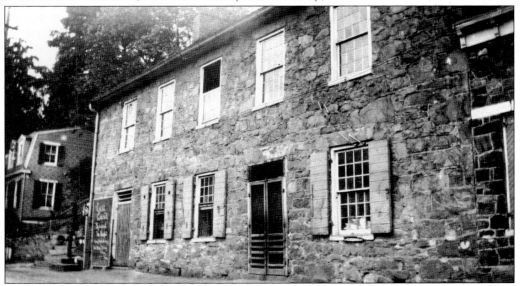

THISTLE COTTON MILL COMPANY STORE, 1910. The mill had its own general store that sold groceries, as well as a few luxury items such as furniture and clothing. In 1910, when this photograph was taken, the store was managed by James Howard Harvey. The company store still stands today, along with a handful of the original cottages, opposite the current paper mill on River Road in Baltimore County. (Courtesy of the Catonsville Room, Baltimore County Public Library.)

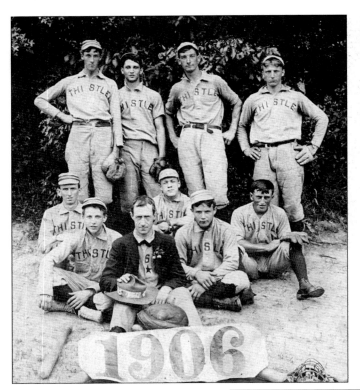

THISTLE BASEBALL TEAM, 1906. Mill towns often had their own baseball teams and marching bands. The gentlemen pictured here were most likely mill workers. Note the large glove in front of the man in the dark jacket. In 1922, the Bartgis Brothers Company bought the mill and converted it into a paper mill. Today the 1837 mill still stands along with much larger, more recently built buildings at 201 River Road. It is owned by Simkins Industries, which mills recycled paper. (Courtesy of the Catonsville Room, Baltimore County Public Library.)

REAR OF THE BURGESS GRIST MILL AND WAGON WORKS, C. 1900. In 1823, George Burgess constructed a gristmill and wagon works on Tiber Creek, a branch of the Patapsco River west of the Ellicott's Mill. The millrace was located on the opposite side of the creek. A conveyor over the creek provided an aqueduct to carry water to the mill. The man on the platform is Samuel W. Burgess, George's son, who took over operation of the mill in 1867 after his father's death. The Burgesses operated the gristmill only three months out of the year. The rest of the year was spent on the wagon works business. (Courtesy of the Howard County Historical Society.)

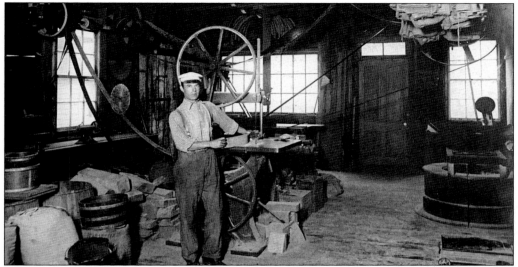

INTERIOR OF THE BURGESS GRIST MILL AND WAGON WORKS, C. 1900. Samuel W. Burgess, pictured here, operated the mill and wagon works until his death in 1906. His son, also named Samuel, ran the mill until 1917, when he converted the building into a Buick dealership and repair shop, which he ran until his death in 1953. The millstone can be seen on the right side of this photograph. (Courtesy of the Howard County Historical Society.)

GEORGE BURGESS'S HOME AND MILLRACE. George Burgess's home was located high on the hill behind his gristmill and wagon works. Note the millrace running along the bottom of the photograph. The home still stands today and continues to be a private residence. The mill and wagon works building, located at 8444 Main Street, has also survived time and natural disasters, and currently is home to Cotter Integrated, Inc., a public relations and advertising firm. (Courtesy of the Howard County Historical Society.)

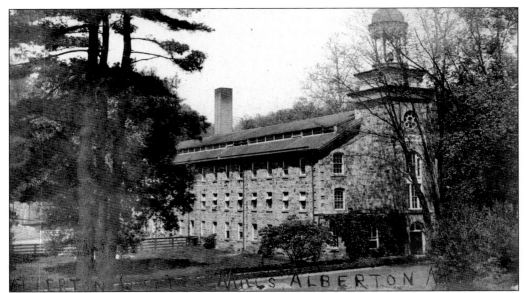

ALBERTON-DANIELS MILL, C. 1909. The first mill on this site was erected in 1840 by the Elysville Manufacturing Company to produce cotton and woolen goods. In the 1850s, Alberton Manufacturing Company purchased the mill and the mill town, which included 106 residents and their homes, an oakum factory, a church, and a school. In 1861, James S. Gary purchased the mill. It was not until Gary that the mill truly prospered. (Courtesy of the Howard County Historical Society.)

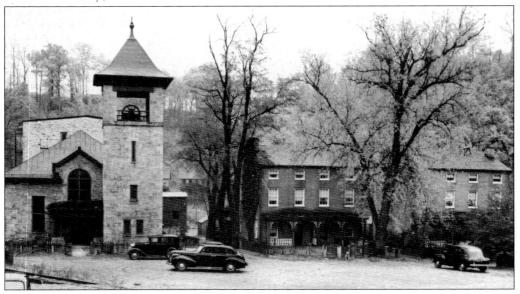

ALBERTON-DANIELS MILL, OCTOBER 1940. During the Civil War, the mill was contracted to provide canvas tents. In November 1940, C. R. Daniels purchased the mill. In 1968, Daniels demolished the workers' cottages rather than bring them up to code. In 1972, Tropical Storm Agnes washed the mill away. In 1973, the mill was placed on the National Register of Historic Places. Today the mill's ruins can be found in the Patapsco Valley State Park. (Courtesy of the Howard County Historical Society.)

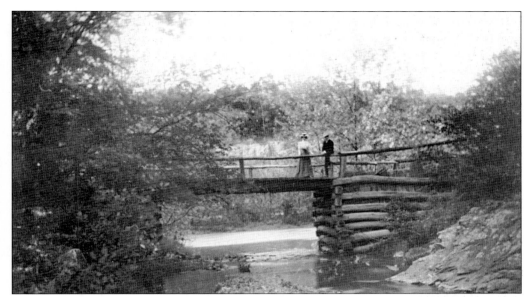

BRIDGE ON THE ROAD TO ORANGE GROVE, C. 1910. In 1856, George Bayly and George Worthington constructed a mill about halfway between the Avalon Dam and Ilchester. It is believed the mill was named Orange Grove for the Osage orange trees that grew in the area. In 1860, C. A. Gambrill, owner of Patapsco Flouring Mill, purchased Orange Grove. The mill produced Orange Grove flour, popular worldwide, from the whitest part of the wheat kernel. (Courtesy of the Catonsville Room, Baltimore County Public Library.)

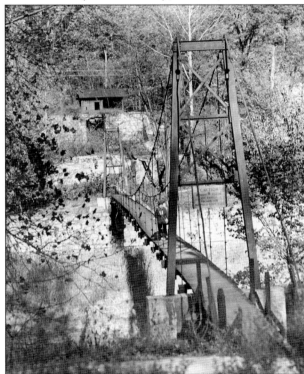

ORANGE GROVE HANGING BRIDGE, C. 1936. The mill was located on the north bank of the Patapsco River. The village of seven houses, a one-room school, and a church were located on the opposite shore. A swinging bridge connected the two sides. In January 1904, ice piled up under the bridge, causing it to collapse, but it was rebuilt. In 1925, after the mill had closed, a group of schoolchildren were visiting the bridge when it collapsed again, tragically killing one child. (Courtesy of the Enoch Pratt Free Library.)

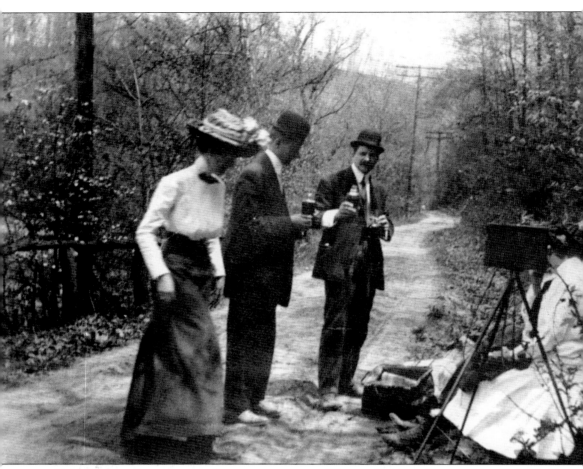

RIVER ROAD, STOPPING FOR LUNCH ALONG THE WAY TO ORANGE GROVE, MAY 7, 1911. On May 1, 1905, the mill came to a fiery end. The fire started in the basement of the engine room, destroying the mill and several homes. The mill was boarded up and abandoned. In 1972, Tropical Storm Agnes washed away the ruins. The area was considered quite picturesque, with sweeping views of the Patapsco River. The dam created a large placid lake reaching as far as Ilchester. This large stretch of backwater attracted picnickers looking to spend a day boating and ice-skaters in the winter. Seen here is a group out for a Sunday stroll stopping on River Road for lunch. By today's standards, they are a bit overdressed. Note that the group had not one but two cameras with them—one that this photograph was taken with and the other that appears in the photograph. Today hikers can walk across the fifth swinging bridge to span the river. On the other side of the bridge, the remains of the Orange Grove Flour Mill can be found with a careful eye. (Courtesy of the Catonsville Room, Baltimore County Public Library.)

Three

THE SCHOOLS

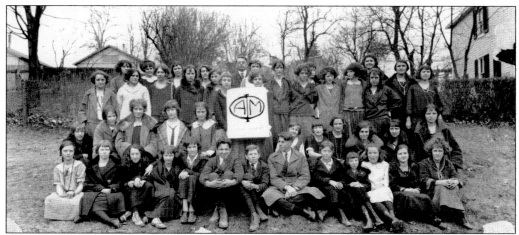

LITERARY SOCIETY, 1923–1927. The members of the society include (first row) Lillian McKenzie (third from left), Bill Cass (eighth from left), and Viola Dewey (far right); (second row) Nikitai Radcliffe (far left), Holding Bauer (second from left), and Clara Kraft (third from left), Elsie Ritchie (far right); (third row) Trimble Radcliffe (fourth from left), and Virginia Watkins (third from right). The other individuals are unidentified. (Courtesy of the Howard County Historical Society.)

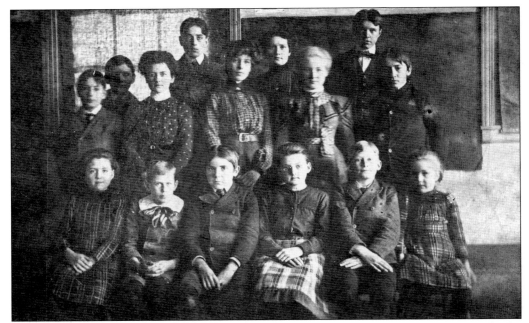

ELLICOTT CITY STUDENTS, C. 1895. Seated in the front row, second from the right, is Charles Meade. The first Ellicott City School was located on the eastern bank of the Patapsco River. In 1820, as the population of Ellicott's Mills grew, it became necessary to divide the students. The boys were transferred to a stone building on Ellicott Street (now Court Avenue). The old schoolhouse is now home to the Howard County Historical Society's research library at 8324 Court Avenue. (Courtesy of the Howard County Historical Society.)

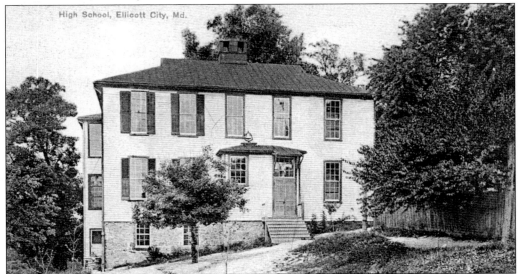

High School, Ellicott City, Md.

ELLICOTT CITY SCHOOL, C. 1919. In 1824, the Ellicott City School moved from Ellicott Street to this building on Strawberry Lane. Strawberry Lane ran north from Court Avenue to School Street, near where the courthouse stands today. The building was demolished in 1925, when the school moved to its new location on College Avenue. Wood and stone were salvaged and used in the construction of houses on Columbia Pike. (Courtesy of the Howard County Historical Society.)

ELLICOTT CITY SCHOOL. Standing outside the Strawberry Lane Ellicott City School are four stern-faced teachers. Pictured from left to right are Mamie Scott, Annie Johnson, and three unidentified people. (Courtesy of the Howard County Historical Society.)

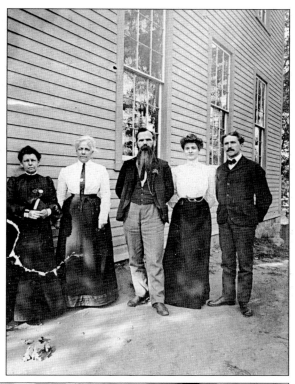

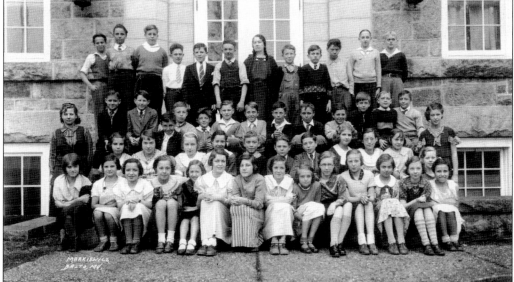

ELLICOTT CITY ELEMENTARY SCHOOL STUDENTS, 1920S. In 1925, the Ellicott City School was completed. It replaced the 1824 school that was located near the courthouse. The new school sat on the site of the ruins of Rock Hill College and was constructed with granite from the college. Today the school has been converted to condominiums, named the Residences at Greystone. The building is located at 3700 College Avenue. (Courtesy of the Howard County Historical Society.)

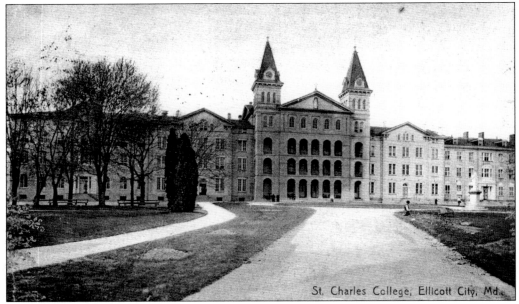

St. Charles College, Ellicott City, Md.

ST. CHARLES COLLEGE. In 1830, Charles Carroll of Carrollton, the only Catholic signer of the Declaration of Independence, donated 253 acres of his land at Doughoregan Manor to the Society of St. Sulpice. The order of priests built a college for seminary studies. The Society of St. Sulpice, founded by Fr. Jean Jacques Olier in Paris in 1642, was an order of secular priests charged with training young men for the priesthood and missionary work. (Courtesy of William Hollifield.)

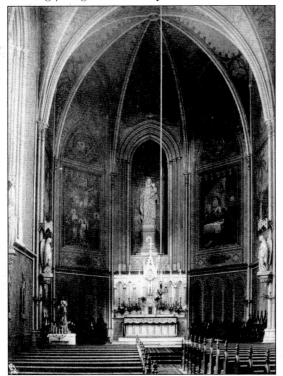

ST. CHARLES COLLEGE CHAPEL. The cornerstone for the new college was laid by Charles Carroll (age 94) on July 11, 1831. Due to financial constraints, the college did not open until 1848. The college was three stories high and partly constructed with local granite. The halls were large, with 15-and-a-half-foot ceilings throughout. The college boasted modern luxuries like gas lighting and radiant heat. The length of the front edifice measured 367 feet. (Courtesy of William Hollifield.)

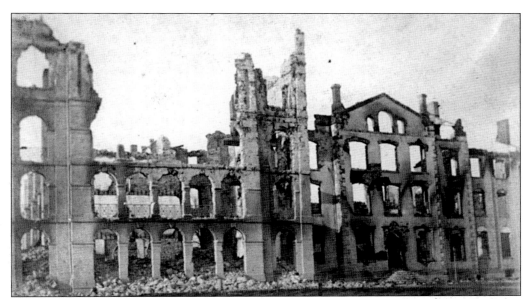

ST. CHARLES COLLEGE RUINS, FRONT VIEW, 1911. The ninth archbishop of Baltimore, James Gibbons, attended the college. By 1898, 900 students had been ordained into the priesthood. In 1911, the college was destroyed by a devastating fire. Fortunately no lives were lost, but no records or belongings survived. The property would later become known as Brendel's Park and Gospel Park. A few ruins remain. The site is currently developed for residential use. (Courtesy of the Howard County Historical Society.)

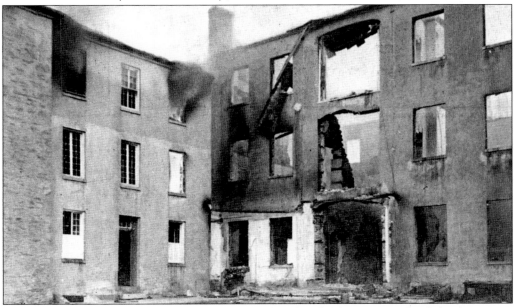

ST. CHARLES COLLEGE RUINS, REAR VIEW, 1911. After the fire in 1911, the Sulpician priests built a new college in Catonsville on Maiden Choice Lane. The college closed its doors in 1977. The property, except Our Lady of the Angels Chapel and the Sulpician community cemetery, was sold and converted into the Charlestown Retirement Community. The Sulpicians continue to staff the chapel. (Courtesy of William Hollifield.)

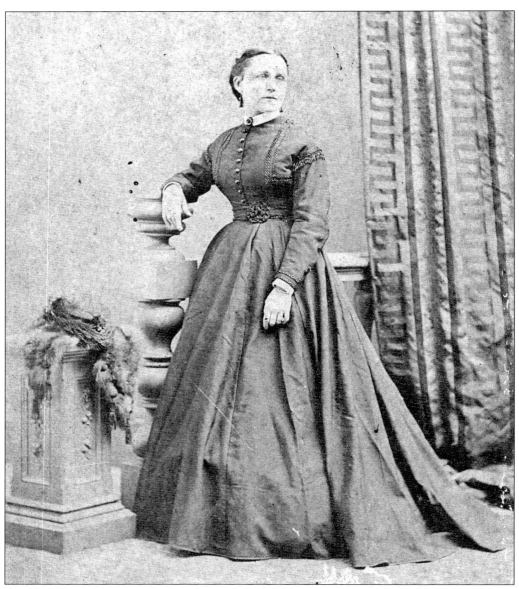

ALMIRA HART LINCOLN PHELPS (1793–1884), HEADMISTRESS OF THE PATAPSCO FEMALE INSTITUTE. Born in 1793, Almira was educated in her early years by her intellectual parents, who stressed reading the classics and mathematics. She gained her love for botany on her family's farm in Berlin, Connecticut. She furthered her education at Berlin Academy, Middlebury Academy in Vermont, and in 1812 at the Pittsfield Female Academy. In 1817, she married Simeon Lincoln, who left her a widow in 1823 with three children. She later married John Phelps of Vermont and had two children with him. When not raising her five children, she spent her early years teaching. In 1841, she accepted the position of headmistress of the Patapsco Female Institute and is given credit for establishing a national reputation for the school. She was largely a self-made professional woman when women's roles were greatly minimized. Almira wrote textbooks on chemistry, biology, botany, physics, and geology for both secondary schools and colleges and amassed a fortune, part of which she turned over to the institute. (Courtesy of William Hollifield.)

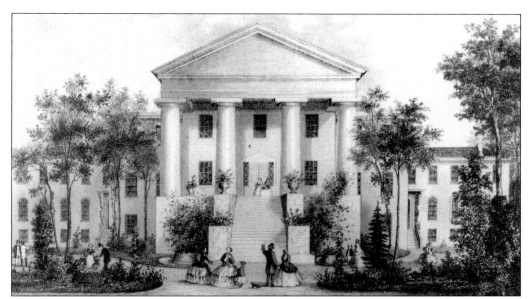

ETCHING OF THE PATAPSCO FEMALE INSTITUTE. The Patapsco Female Institute was established in January 1837 for girls aged 12 to 18 on land given primarily by the Ellicotts. It was designed by Robert Carey Long Jr., who designed many outstanding buildings in Baltimore. The school almost closed after two years due to lack of enrollment. It opened sooner than it should have and was not adequately advertised. Under the direction of Almira, the school gained prestige. (Courtesy of the Enoch Pratt Free Library.)

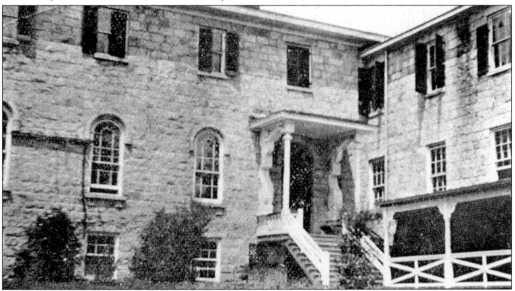

THE PATAPSCO FEMALE INSTITUTE INTERIOR COURTYARD. Almira believed that young women should obtain not just an ordinary finishing school "education" but also be prepared to earn a living. Many graduates went out as teachers. Some took over management of Southern plantations when their husbands went off to the Civil War. Almira was succeeded by Sarah Nicholas Randolph, great-great-granddaughter of Thomas Jefferson. A decline in enrollment began during the Civil War, and the school never recovered. It closed in 1891. (Courtesy of William Hollifield.)

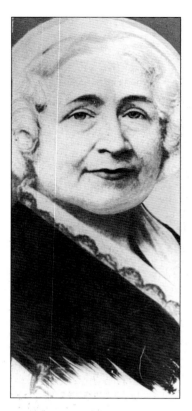

ALMIRA HART LINCOLN PHELPS, C. 1880. Almira retired as headmistress of the Patapsco Female Institute in 1858, after her daughter, Jane Lincoln, was killed in a train accident. In her retirement, she wrote and lectured on numerous social causes, in particular support of the Union during the Civil War. She continued to be an advocate of formal education for women. She often told her students, "far from considering that you know everything, you must think you have almost everything to learn." (Courtesy of the Enoch Pratt Free Library.)

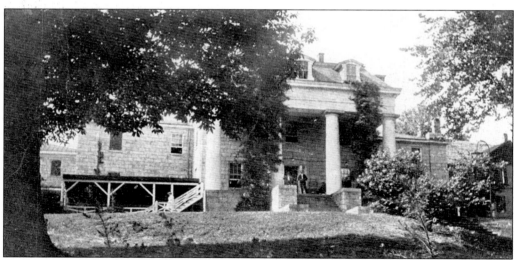

BERG ALNWICK. In 1891, Lilly Tyson Elliott (not to be confused with Ellicott) purchased the former Patapsco Female Institute. She named it Berg Alnwick (or Burg Olynwyck) after the ancestral 12th-century Alnwick Castle in Northumberland, England. She restored the magnificent building and later converted her home to an exclusive summer retreat. Lilly's father, James E. Tyson, helped obtain the property. As a gesture of gratitude, she is said to have kept a pipe on every mantle for his convenience when visiting. (Courtesy of William Hollifield.)

BERG ALNWICK. Berg Alnwick has been compared to the Red Lion Inn in Stockbridge, Massachusetts, and was considered as elegant. Business declined with the outbreak of World War I. Lilly offered the building for use as a convalescent hospital; it became known as the Maryland Women's War Relief Hospital. After the war, the building was briefly the home of Lilly's daughter, Mrs. ? Parker. In the mid-1930s, the Hilltop Theatre, under the direction of Don Swann Jr., took over the property. The theater closed when World War II began. (Courtesy of the Howard County Historical Society.)

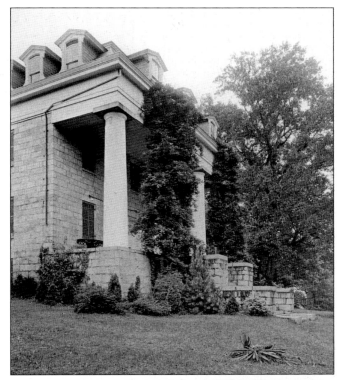

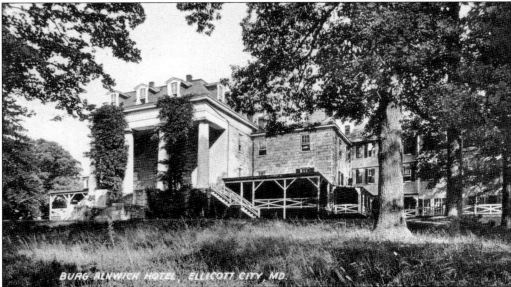

BURG ALNWICK HOTEL, ELLICOTT CITY, MD.

BERG ALNWICK. After World War II, Berg Alnwick changed hands several times. The condition of the property steadily declined and was abandoned by the 1960s. The owner at the time, Dr. James Whisman, willed the property to the University of Cincinnati. In 1966, it was purchased by Howard County for $17,500. Today visitors can enjoy the historical park, climb the ruins, and enjoy the view of the Patapsco River. It is said that you may even run into the spirits of the former students who can't bear to leave their beloved school. (Courtesy of William Hollifield.)

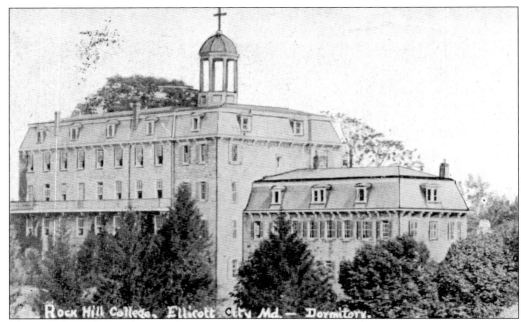

ROCK HILL COLLEGE. Isaac Sams (born 1788 in Bath, England) came to Maryland in 1818. In 1822, he rented a house outside of Ellicott's Mills and operated Sams' Academy for Boys. In 1824, he purchased land from the Ellicotts and built Rock Hill Academy. The Christian Brothers purchased the property in 1857. During the Civil War, the academy became an institute. After 1865, it was elevated to a college. (Courtesy of the author's collection.)

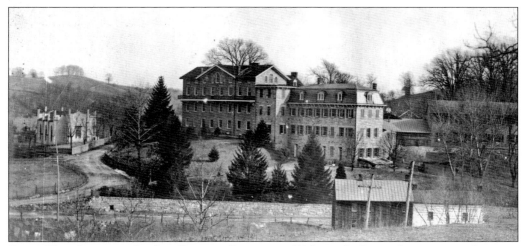

ROCK HILL COLLEGE. Student Dettmar Passvants of Zelienople, Pennsylvania, wrote home to his mother on May 23, 1828: "We are going to have a dancing Master & Father said I should also lern to break me of my clumsy walk. Mr. Sams has between 30–40 boys. . . . We have two boys that come from Spain & three that come from Mexico & Cuba. I saw the two Miss Craigs. Isabella is to my eye extremely ugly & Emily is not as handsome as she used to be." (Courtesy of the Howard County Historical Society.)

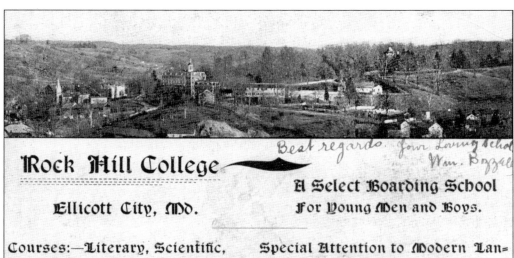

Rock Hill College

A Select Boarding School

Ellicott City, Md.

For Young Men and Boys.

Courses:—Literary, Scientific, Commercial, Preparatory.

Special Attention to Modern Languages and the Sciences.

*Best regards. Your Loving Scho...
Wm. Bozzell*

ROCK HILL COLLEGE ADVERTISEMENT POSTCARD. On the night of January 23, 1923, while the entire student body was attending a basketball game in the gym, sparks from a chimney started a fire under the roof of the dormitory. Low water pressure made it extremely difficult for the fire department to control the fire. All buildings except the gym were lost. Stones from the college were later used to build the Ellicott City High School, which now houses the Residences at Greystone on College Avenue. (Courtesy of William Hollifield.)

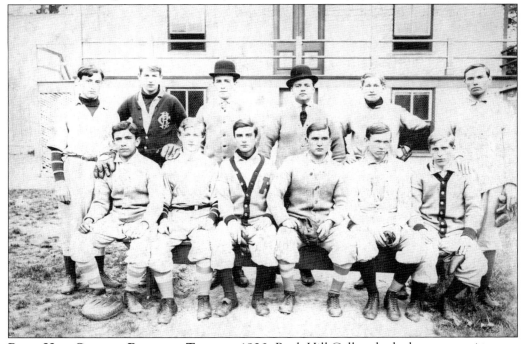

ROCK HILL COLLEGE BASEBALL TEAM, C. 1920. Rock Hill College had a large recreation area known as Forty Acres on New Cut Road. Besides having a baseball team, the college had a football team from 1894 to 1922. (Courtesy of the Howard County Historical Society.)

COLLEGIATE DEPARTMENT.

Freshman Class.

No. Students, *18*; Relative Standing, *18*

Conduct	*100*	Logic	
Attention to Study	*80*	Metaphysics	
Christian Doctrine	*56*	Ethics	
Arithmetic	*75*	Philosophy of History	
Book-Keeping		Philosophy of Literature	
Algebra	*60*	Philosophy of Style	
Geometry	*75*	Astronomy	
Mensuration	*75*	Geology	
Trigonometry		Botany	
Surveying		Conic Sections	
Navigation		Calculus	
Physics	*95*	Analytical Mechanics	
Chemistry	*40*	Civil Engineering	
Physical Geography	*65*	Drawing	*100*
Rhetoric	*56*	Latin	*75*
History	*63*	Greek	*33*
Elocution		French	*67*
Essay Writing	*64*	German	
English Literature		Music	
English Classics		Written Exercises	

Tho. Blandin Professor.

ROCK HILL COLLEGE REPORT CARD. This is the monthly report card of John F. McMullen, who was in his freshman year at Rock Hill College. John may have had a bit of explaining to do after his parents received this report. Of 18 students in his class, he ranked number 18. (Courtesy of William Hollifield.)

Four

THE CHURCHES

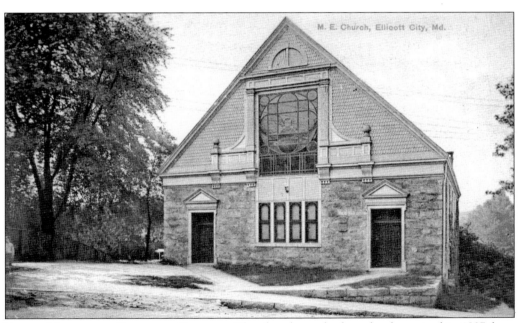

EMORY METHODIST EPISCOPAL CHURCH. The church was built on land acquired in 1837 from Samuel Ellicott, stipulating that the land be used "to preach and expound God's Holy Word." Originally the entrance was on the west side, but an 1887 renovation moved the entrance to the south side. In the early days of the congregation, the men and women were divided into separate seating arrangements. When the church was remodeled in 1887, the restricted seating was eliminated. The church is located at 21 Church Road. (Courtesy of William Hollifield.)

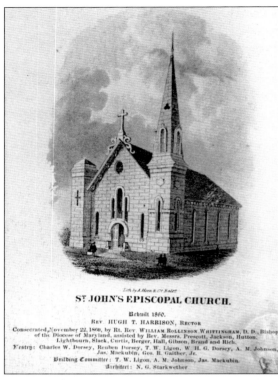

ST. JOHN'S EPISCOPAL CHURCH.

Rebuilt 1860.

REV. HUGH T. HARRISON, RECTOR

Consecrated November 22, 1860, by Rt. Rev. WILLIAM ROLLINSON WHITTINGHAM, D. D., Bishop
of the Diocese of Maryland, assisted by Rev. Messrs. Prescott, Jackson, Hutton,
Lightbourn, Slack, Curtis, Berger, Hall, Gibson, Brand and Rich.

Vestry: Charles W. Dorsey, Reuben Dorsey, T. W. Ligon, W. H. G. Dorsey, A. M. Johnson,
Jas. Mackubin, Geo. R. Gaither, Jr.

Building Committee: T. W. Ligon, A. M. Johnson, Jas. Mackubin.

Architect: N. G. Starkwether.

ST. JOHN'S EPISCOPAL CHURCH LITHOGRAPH. The land on which the church was built was deeded by Caleb Dorsey and his wife, Elizabeth, in 1825. It was to be a chapel of ease, since the existing Episcopal church, Christ Church in Elkridge Landing, was too far for the worshippers in Ellicott's Mills. The first church on this site faced north and accommodated 200 worshippers and a gallery for servants. (Courtesy of the Howard County Historical Society.)

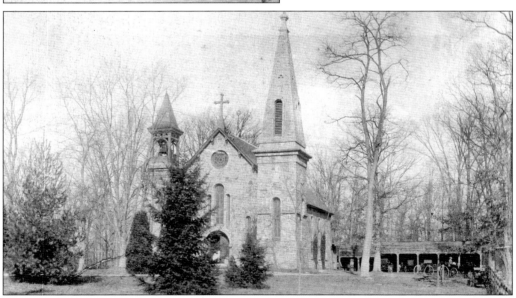

ST. JOHN'S EPISCOPAL CHURCH, C. 1910. In 1859, a new church replaced the "white church." Nathan Gibson Starkweather of New York City, a leading ecclesiastical architect and a founder of the American Institute of Architects, designed it. The church on the spot today has one of only 12 solid stone church steeples in the country. In 1971, the church was extended by 43 feet on the altar end to accommodate the growing congregation. The church is located at 9120 Frederick Road. (Courtesy of the Howard County Historical Society.)

FIRST PRESBYTERIAN CHURCH. The church started as a mission in 1837 at Thistle Mills, two miles down the Patapsco River from Ellicott's Mills. The members worshipped in the mission chapel built by the Thistle Mill Company. In 1844, the congregation moved to a newly constructed stone church in Ellicott's Mills. In 1894, the front wall of the church collapsed during an excavation to add schoolrooms, and the current structure was built in its place. (Courtesy of William Hollifield.)

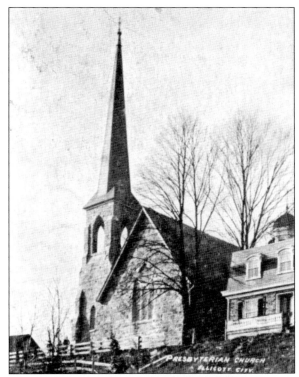

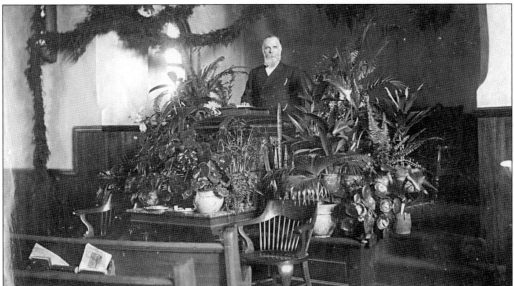

REV. HENRY BRANCH, PASTOR OF FIRST PRESBYTERIAN CHURCH, IN PULPIT C. 1905. In 1959, the church relocated to Columbia, Maryland. It was anticipated that with the development of Columbia, the church would need a bigger home more centrally located in Howard County. The old church building is currently home to the Howard County Historical Society Museum. Pictured is Rev. Henry Branch, who served as minister from 1882 to 1909. (Courtesy of the Howard County Historical Society.)

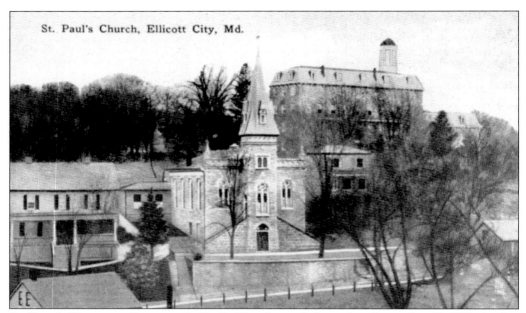

St. Paul's Church, Ellicott City, Md.

ST. PAUL'S CATHOLIC CHURCH. St. Paul's Church was dedicated on September 13, 1838. At that time, it was the only Catholic church between Baltimore and Frederick. Previously area Catholics worshipped in St. Mary's Chapel at nearby Doughoregan Manor. The church was built of local gray granite and was very plain inside. During the Civil War, the basement of the church served as a hospital for all soldiers, both Union and Confederate. (Courtesy of William Hollifield.)

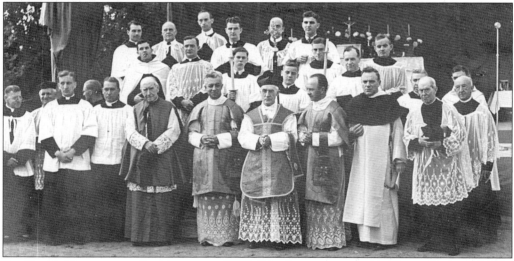

ST. PAUL'S CENTENARY CELEBRATION, 1938. The first pastor was Fr. Henry Coskery (1835–1839), who also founded the Christian Brothers' Rock Hill College in 1857. Fr. William E. Starr (1870–1873) renovated the interior, adding frescoes, carved wooden angels, and German silver chandeliers. Pictured are (first row) seven unidentified people, Rev. Msgr. Michael Ryan, pastor (center, with hat), and six unidentified people; (second row) two unidentified people, Michael Renehan, ? Kinlein, Joseph Stigler, and two unidentified people; (third row) Rev. Joseph McAllister, two unidentified people, Donald Powers, unidentified, and Sam Powers. (Courtesy of the Howard County Historical Society.)

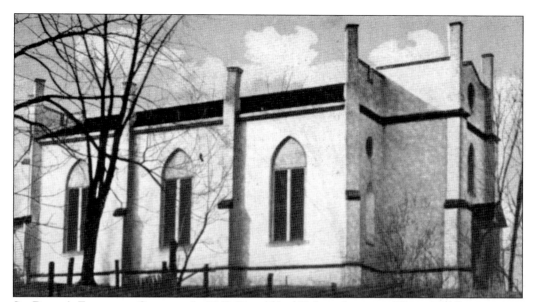

ST. PETER'S EPISCOPAL CHURCH. In 1842, Rev. Alfred Holmead came to Ellicott's Mills to serve as chaplain of the Patapsco Female Institute. In 1845, he organized Grace Church, which changed its name to St. Peter's in 1848 to avoid confusion with the congregation in Elkridge Landing. The church was built on the bluff behind St. Paul's Church. In 1939, the church burned and the congregation rebuilt the church that now stands on Rogers Avenue. (Courtesy of William Hollifield.)

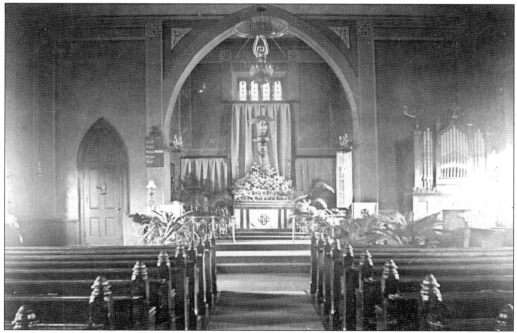

ST. PETER'S EPISCOPAL CHURCH, INTERIOR, 1900. The church is seen here decorated for the Willie Worthington Hodges and Thomas Douglas Temple wedding on October 31, 1900. The photograph was donated to the Howard County Historical Society by their daughter Roberta J. Adams. (Courtesy of the Howard County Historical Society.)

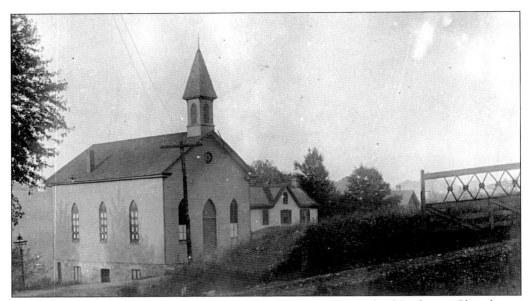

FIRST EVANGELICAL LUTHERAN CHURCH. In 1874, First Evangelical Lutheran Church was founded by German immigrants. Previously the Ellicott's Mills Lutherans traveled to Catonsville to worship. The congregation worshipped here for 81 years. In 1956, a larger church was built on land donated by Mr. and Mrs. Charles Miller overlooking the Patapsco River. The old two-story frame church has been converted into a private residence and is located at 3761 Church Road. (Courtesy of the Howard County Historical Society.)

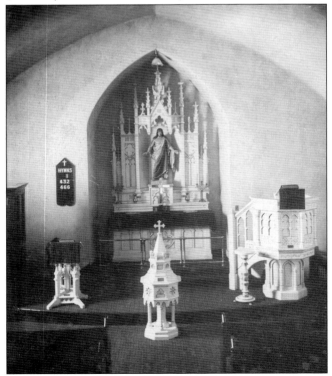

CHANCEL OF FIRST EVANGELICAL LUTHERAN CHURCH. Seen here is the chancel of First Evangelical Lutheran Church sometime before 1950. Note the ornate altar, pulpit, and baptismal font. (Courtesy of the Howard County Historical Society.)

Five

THE HOMES

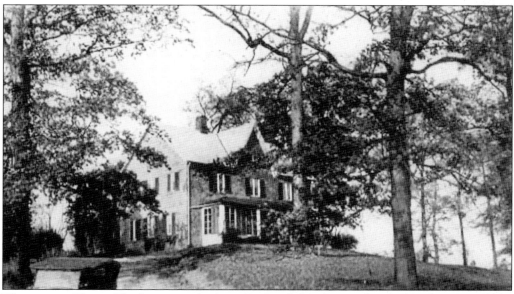

WOODLAWN HALL. The house was built on Frederick Road around 1850 for John Dorsey, son of Judge Thomas Beale Dorsey. A popular story is that Dorsey laid out his property with two driveways, one toward Frederick and the other toward Baltimore, to avoid the nearby tollgate. The house's last resident in the 1990s was a French restaurant called Papillon. The house was torn down to make way for the Papillon community. (Courtesy of the author's collection.)

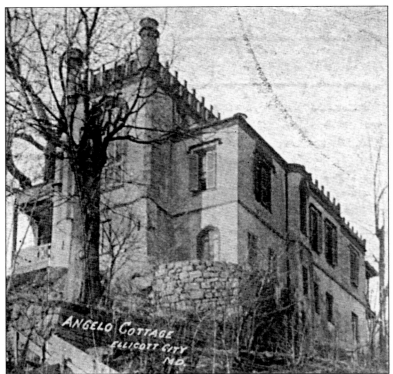

ANGELO COTTAGE. Until 1972, it was believed that Samuel Vaughn, a Frenchman, had built the home. In 1972, an 1877 article was discovered (reprinted from 1833) in the *Maryland Journal*, reporting that the home was built by Alfred S. Waugh (1810–1856) in 1833. Waugh was a well-known painter of panoramas. The house was named after Michelangelo. The house, made of granite and imported lumber, was covered in yellow stucco. (Courtesy of William Hollifield.)

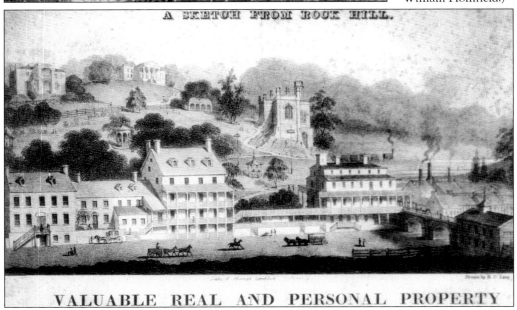

ANGELO COTTAGE LOTTERY POSTER. The 1877 account listed Andrew McLaughlin as "Lord of the Soil," which may have been a reference to what is now known as ground rent. In 1834, a year after it was built, records show that McLaughlin held a great lottery of his estates and Angelo Cottage was one of the first prizes. Seen is a copy of one of the lottery posters depicting a sketch by R. C. Long. (Courtesy of the Enoch Pratt Free Library.)

ANGELO COTTAGE, C. 1912.
The house was purchased by
Samuel H. Watkins from John T.
Ray in 1912. Watkins shingled
over the stucco exterior and
removed the portico. Watkins's
daughter, Virginia Watkins
Hazel, lived in the house all her
life, until 1968. She was known
to open her door to anyone
interested in her beloved house.
It is believed that H. L. Mencken
often visited to hear stories of
the house's past. (Courtesy of the
Enoch Pratt Free Library.)

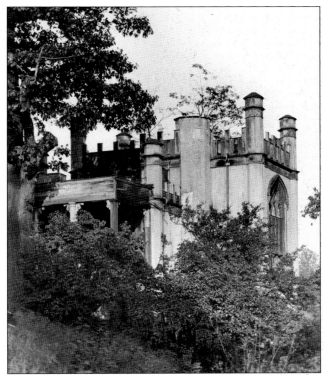

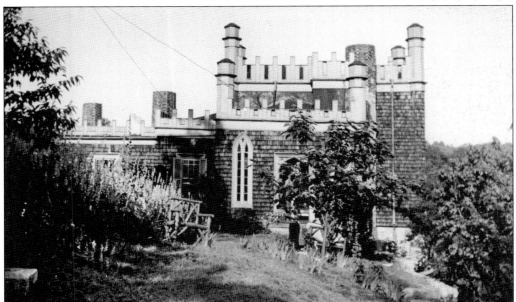

ANGELO COTTAGE, C. 1935. Every notable home seems to have a ghost story. It is said that a spirit haunts the cottage's basement and if provoked will drag you down a narrow hole into the river. Angelo Cottage remains a private residence. Wooden siding has replaced the cedar shingles. The cottage is located at 3791 Church Road and can be seen perched high on the hill over the Patapsco River. (Courtesy of the Enoch Pratt Free Library.)

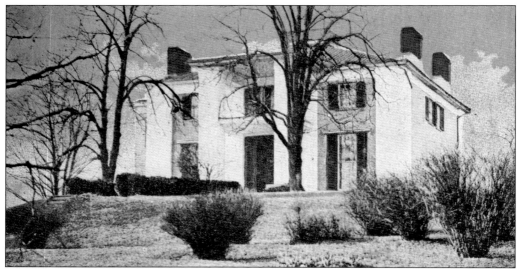

MOUNT IDA. In 1828, William Ellicott, grandson of Andrew Ellicott, built Mount Ida. It was the last home built by an Ellicott in Ellicott's Mills. Judge John Snowden Tyson was the next owner. Tyson's unmarried daughters lived in the house all their lives. The last daughter, Ida, after whom it is believed the house was named, lived in the home well into her 90s. (Courtesy of William Hollifield.)

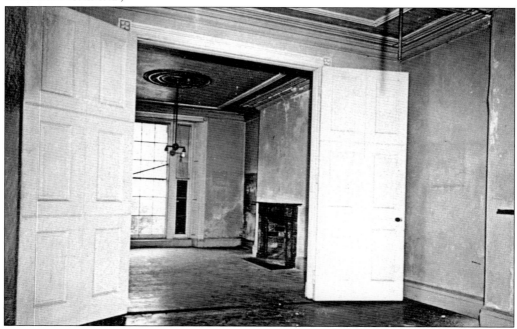

MOUNT IDA, VIEW FROM SOUTH PARLOR INTO THE NORTH PARLOR, 1964. In 1930, after Ida Tyson's death, Mr. and Mrs. Louis Clark purchased the home and lived there until 1959. Mount Ida was abandoned after the Clarks' deaths. By 1970, plans were underway to tear down the once-grand home and build offices in its place. Charles Miller and the Miller Land Company purchased Mount Ida and saved it from the wrecking ball. (Courtesy of the Howard County Historical Society.)

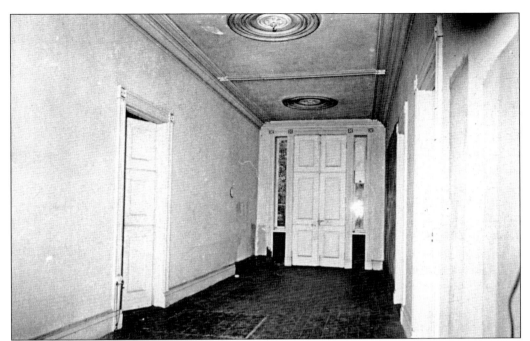

MOUNT IDA, FRONT HALL, 1964. The Miller Land Company stabilized Mount Ida and turned it into office space. Currently the Friends of the Patapsco Female Institute occupy the building, using it as a visitor's center for the Patapsco Female Institute Historic Park, located across the street from Mount Ida. Mount Ida is located at 3691 Sarah's Lane. (Courtesy of the Howard County Historical Society.)

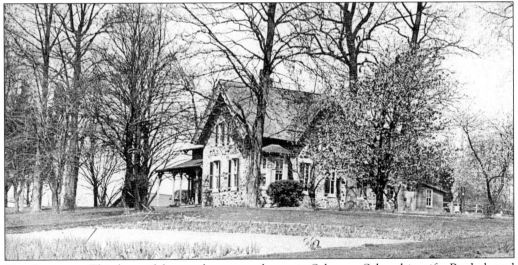

THE LINDENS. This beautiful stone house was home to Sylvanus Sykes, his wife, Rachel, and their family for many years. The Sykes came to Ellicott's Mills in 1844. Sylvanus had studied dentistry in London and practiced until his death in 1872. His sons Claude and Mordecai were also dentists. Mordecai was the first elected mayor of Ellicott City in 1889. Today the house, located at 8514 Chapel View Road, is still a private residence. (Courtesy of the Howard County Historical Society.)

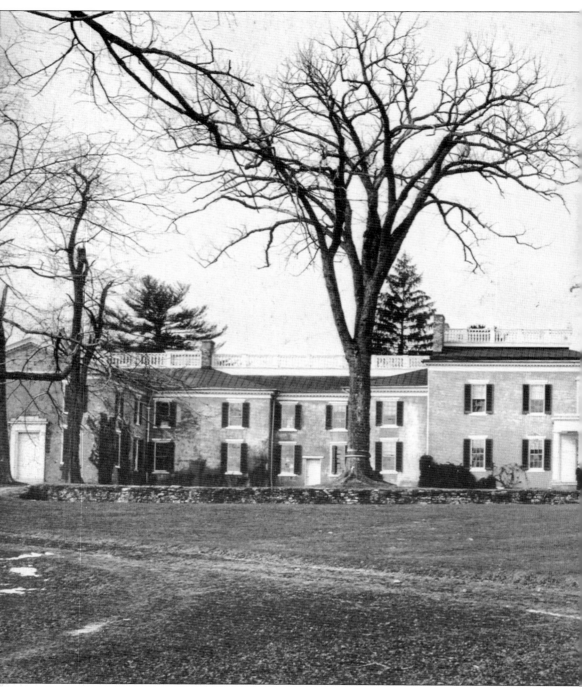

DOUGHOREGAN MANOR. This magnificent Colonial estate was home to Charles Carroll III of Carrollton, the only Catholic signer of the Declaration of Independence. Charles Carroll II of Annapolis built the first section of the home. The exact date of its construction is not known but is believed to be between 1717 and 1727. Charles III continued construction and expanded upon his father's original plans. Charles II gave his son land in Frederick County, on which he built

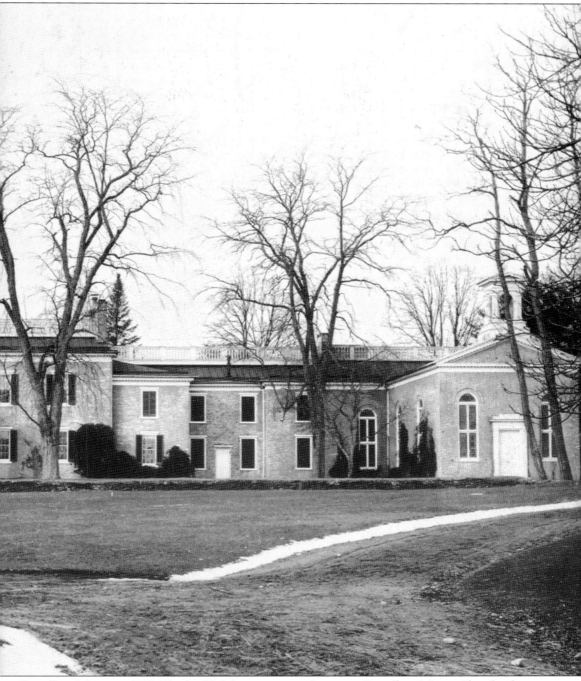

Carrollton Manor in 1765. Charles III did not spent much time at Carrollton Manor. Shortly after he had constructed it, his father died, and he preferred to spend his time at Doughoregan Manor. When asked why he was not known as "Charles Carroll of Doughoregan," his answer was of a practical nature—it was easier to spell Carrollton. (Courtesy of the Enoch Pratt Free Library.)

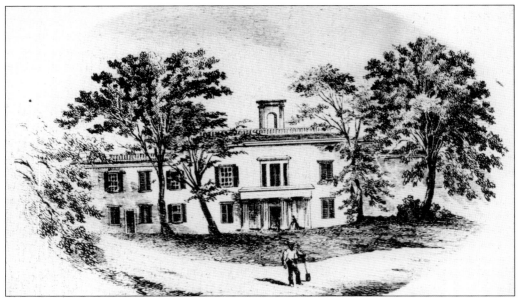

DOUGHOREGAN MANOR ETCHING. Charles Carroll supported the Ellicott brothers when they arrived in the Patapsco Valley, both financially and intellectually. Before the arrival of the Ellicotts, tobacco, the crop of choice in Maryland, was stripping the soil of nutrients. Carroll adopted the Ellicotts' belief that wheat would be as profitable and less harmful. Carroll built the road from his manor to the mills so that the Ellicotts could process his wheat. (Courtesy of the Enoch Pratt Free Library.)

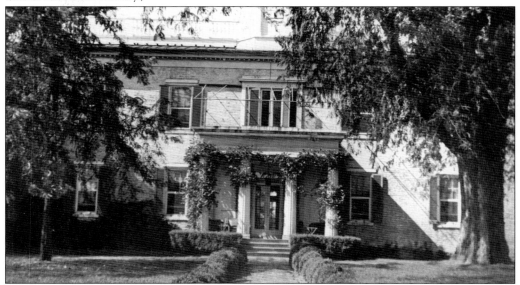

DOUGHOREGAN MANOR MAIN ENTRANCE, 1935. In the 1830s, Charles Carroll V undertook a comprehensive expansion in the Greek Revival style, converting the manor to its present five-part composition. He raised the main house to two stories and cut off the gable roof to form a flat deck. The kitchen and servants' quarters and the chapel were originally stand-alone structures. Charles V connected them to the main house by two-story wings. (Courtesy of the Enoch Pratt Free Library.)

ST. MARY'S CHAPEL AT DOUGHOREGAN MANOR, 1937. The chapel was originally built as a separate structure, but as the main house was extended, it became a wing. It is one of few remaining privately owned Catholic chapels in the country. In 1832, at the age of 96, Charles Carroll III of Carrollton died. He was the last survivor of the signers of the Declaration of Independence. Carroll is buried next to the altar, forever resting in peace at his beloved Doughoregan Manor. (Courtesy of the Enoch Pratt Free Library.)

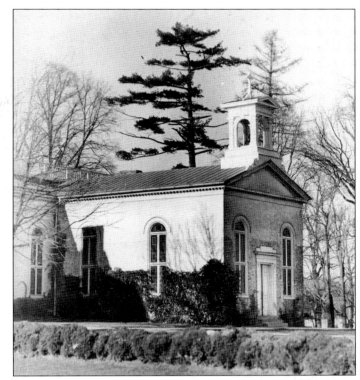

DOUGHOREGAN MANOR BLACKSMITH SHOP, C. 1885. This photograph was taken by Emily Spencer Hayden, a noted photographer from Catonsville. Today Doughoregan Manor is still a working farm on over 800 acres of the original estate. The property has continuously been owned by Charles Carroll's descendants and is closed to the public. The ornate gatehouse can be seen on Frederick Road at the top of Manor Lane, a private drive. (Courtesy of the Enoch Pratt Free Library.)

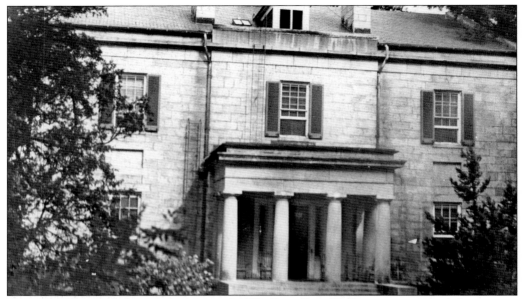

FOLLY QUARTER. Built sometime around 1832, Carrollton Hall, as it was named then, was a wedding gift from Charles Carroll of Carrollton to his favorite granddaughter, Emily Caton, and her husband, John Mactavish. Mactavish was a British consul for the port of Baltimore. Mactavish renamed Carrollton Hall Folly Hall after an estate owned by the Mactavish family in Scotland. It is believed the Quarter came from the estate being built upon a 1,000-acre corner of Doughoregan Manor. (Courtesy of the Enoch Pratt Free Library.)

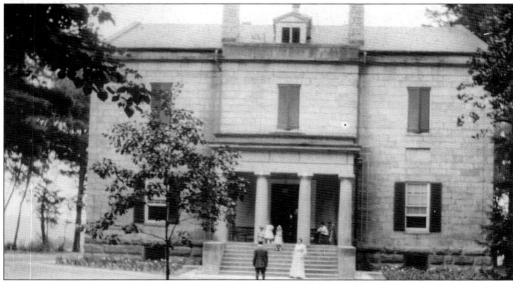

FOLLY QUARTER, C. 1914. After Emily Mactavish's death in 1867, the house was sold to Baltimore merchant Charles M. Dougherty for use as a summer home until he sold it in 1881 to Royal Phelps of New York. John Lee Carroll, governor of Maryland from 1876 to 1880, married Anita, the daughter of Royal, thereby returning Folly Quarter to the Carroll family. Charles Carroll, the son of the governor, inherited the house and allowed it to fall into disrepair. (Courtesy of the Enoch Pratt Free Library.)

FOLLY QUARTER MANTEL, C. 1914. In 1910, Van Lear Black, publisher of the *Baltimore Sun*, purchased the house, rescuing it from neglect and abuse. Mr. Black enjoyed throwing enormous parties for 700 or more invitees, including Pres. Warren G. Harding, a personal friend. In 1924, Van sold the house to Morris Schapiro, the president of the Boston Iron and Metal Company, who in turn sold the manor to the Franciscan friars in 1928. (Courtesy of the Enoch Pratt Free Library.)

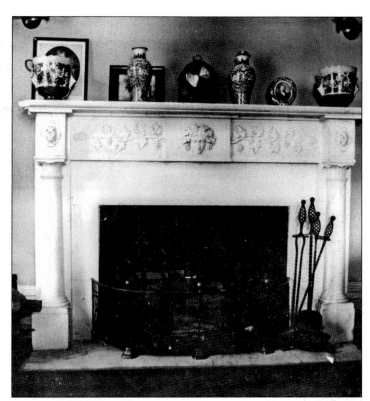

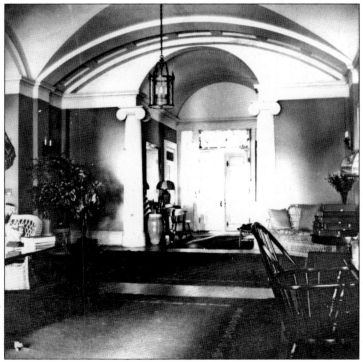

FOLLY QUARTER ENTRANCE, C. 1914. The friars quickly outgrew the manor house and, in 1930, built a 20,194-square-foot friary; the manor house became the Mission House. In 1995, the Shrine of St. Anthony, with the gift of a major relic of St. Anthony from the Basilica of St. Anthony in Padua, became part of the friary. Today the public is welcome to worship with the friars in their chapel at 12300 Folly Quarter Road. (Courtesy of the Enoch Pratt Free Library.)

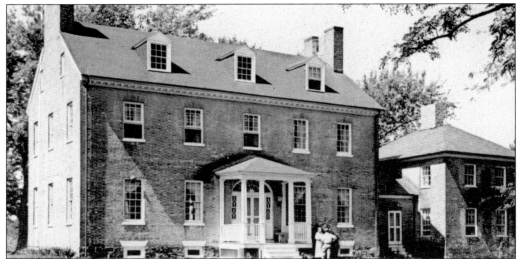

BURLEIGH MANOR, 1936. Burleigh Manor was built around 1802 by Col. Rezin Hammond (1745–1809) for his great-nephew Denton Hammond. Colonel Hammond was a Revolutionary War leader who participated in the Maryland Tea Party and the burning of the *Peggy Stewart* in Annapolis. Matthias Hammond inherited the estate after the death of his father, Denton, in 1832. The estate remained in the family until 1928. (Courtesy of the Howard County Historical Society.)

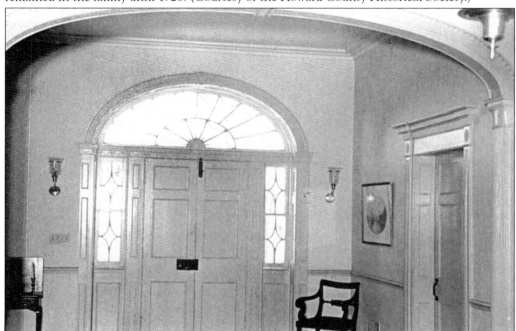

BURLEIGH MANOR ENTRANCE, 1936. In 1935, Charles McAlpin Pyle purchased the manor. In 1941, it became the home of Prince Alexandre Hohenlohe of Austria and Princess Peggy. In 1946, St. Timothy's School considered using the building for its school but settled on a site in Stevenson instead. Seen in this photograph is the main entrance of the manor. Note the intricate starburst fanlight above the door and the elliptical arch leading into the main hall. (Courtesy of the Howard County Historical Society.)

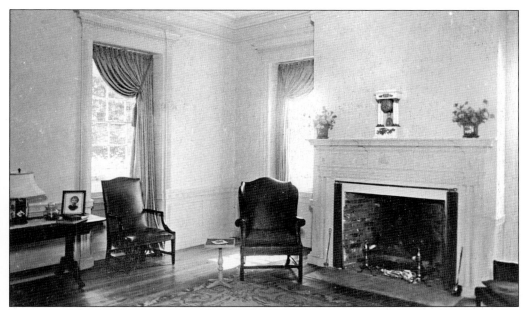

BURLEIGH MANOR DRAWING ROOM, 1936. In 1946, the manor was owned by George Dudley Iverson IV and subsequently by his son, George V. Seen in this photograph is the mantel, which continues the starburst theme in its woodwork. Other woodwork in the room has an H pattern repeated in its detail. Most likely the H stands for Hammond, the original owners. (Courtesy of the Enoch Pratt Free Library.)

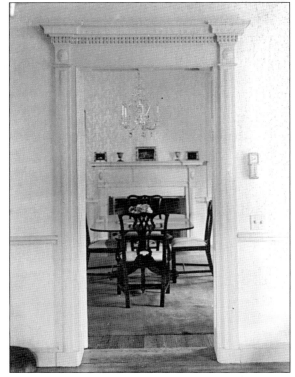

BURLEIGH MANOR VIEW OF DINING ROOM, 1936. In 1936, the manor was documented by the Historic American Buildings Survey and the Historic American Engineering Record collections. The collection is among the largest and most heavily used in the Prints and Photographs Division of the Library of Congress. The home still stands on Centennial Lane. (Courtesy of the Enoch Pratt Free Library.)

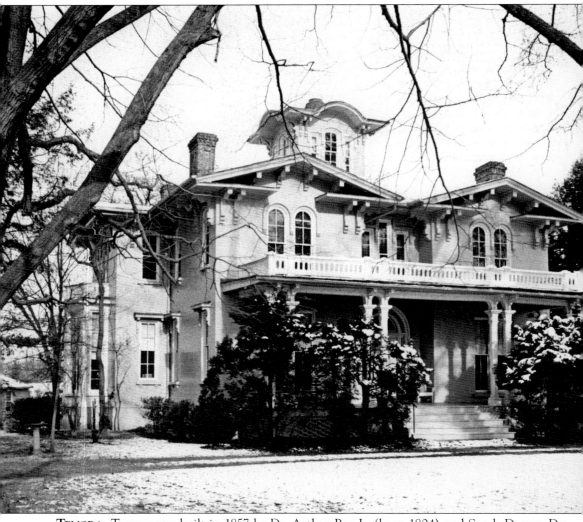

TEMORA. Temora was built in 1857 by Dr. Arthur Pue Jr. (born 1804) and Sarah Dorsey. Dr. Pue was one of the founders of the Medical and Chirurgical Faculty of Maryland. One morning during the Civil War, the Pues sat down to breakfast to find no food on the table or servants in sight. Upon investigation, Dr. Pue was alarmed to find his kitchen, located in the basement, filled with Union soldiers helping themselves to his breakfast. (Courtesy of the Howard County Historical Society.)

TEMORA, SECOND-FLOOR STUDY.
Temora remained in the Pue family
until 1913, when it was purchased by
Edwin Fulton Hanna Sr. The house
remained in the Hanna family for
almost 70 years. The beautiful Italianate
home was designed by Norris Garshon
Starkweather (1818–1885) and is
considered one of his best-known
designs. Today the home remains a
private residence at 4300 Temora Manor
Lane. (Courtesy of the Howard County
Historical Society.)

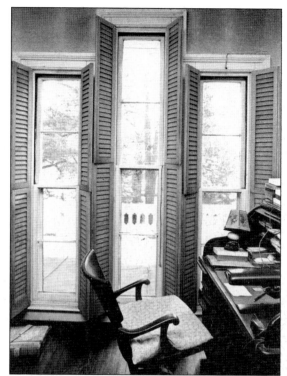

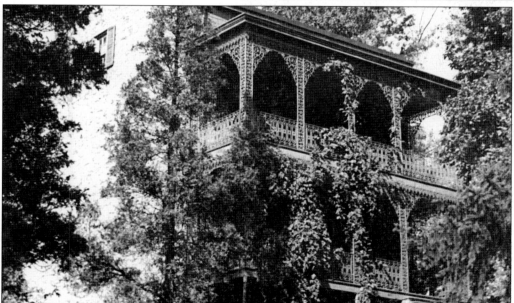

OAK LAWN, 1939. Oak Lawn was built in 1840 by Edwin Parsons Hayden (1811–1850), a lawyer.
In 1937, the home was acquired by Howard County and became the headquarters of the Board of
Education. In 1970, the home served as the Peoples' Court. Since 1986, the building has become
physically incorporated into the courthouse structure, but its lovely ornate iron balconies allow
it to retain its air of grandeur. (Courtesy of the Enoch Pratt Free Library.)

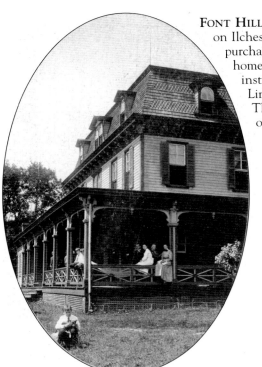

FONT HILL. Font Hill was built *c.* 1875 and was located on Ilchester Road. Dr. Samuel Jayne Fort (1859–1925) purchased the property in 1886 for $5,000 for use as a home for "feeble-minded individuals." It was the first institution of its kind south of the Mason-Dixon Line. Dr. Fort's son Alfred is seen in the foreground. The other individuals are unidentified. (Courtesy of Alice Fort.)

DR. SAMUEL JAYNE FORT ON HORSEBACK. Dr. Fort was a firm believer in national defense. He gave a large portion of his spare time to state military organizations. He was one of the original members of Troop A. Dr. Fort was appointed major, chief of ordinance, and inspector of small arms in the National Guard. He served during World War I at Camps Perry, Dodge, and Benning despite his age. (Courtesy of Alice Fort.)

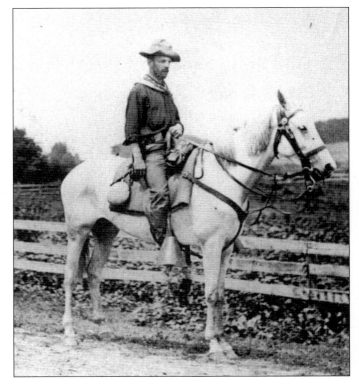

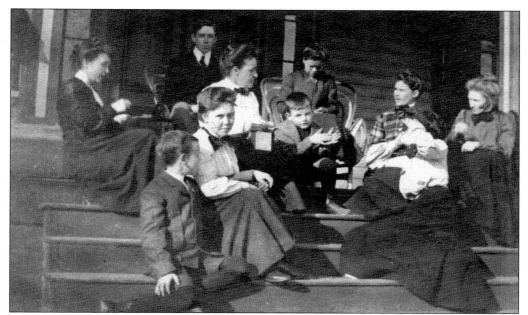

ON THE FRONT PORCH OF FONT HILL. Dr. Fort and his wife, Caroline Wetherbee Fort, raised six children at Font Hill. Sons Wetherbee and Alfred followed in their father's footsteps and became physicians. Pictured here are Caroline Wetherbee Fort (at far left); Wetherbee Fort (center, boy clapping); Marian Fort Stedman, Dr. Fort's sister, (to the left of Wetherbee); and Alfred Fort (bottom left). The other individuals are unidentified. (Courtesy of Alice Fort.)

ANNIE OAKLEY AND HUSBAND, FRANK E. BUTLER, C. 1913. Dr. Fort was an award-winning pistol and revolver shot. While pursuing his favorite pastime, Dr. Fort befriended Annie Oakley. Annie was a famous markswoman traveling with Buffalo Bill's Wild West Show. She often visited Dr. Fort at Font Hill and engaged him in some friendly shooting competitions on the front lawn. Annie and her husband, Frank E. Butler, also a noted marksman, were residing at the time in Cambridge, Maryland. (Courtesy of Alice Fort.)

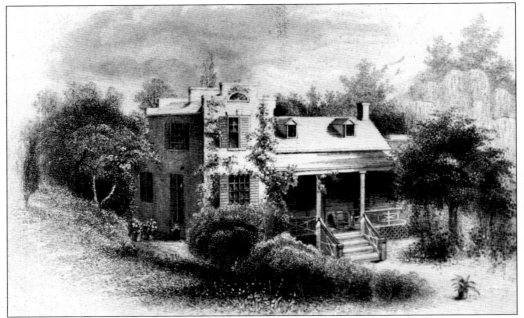

PATAPSCO. Patapsco was built by Edward Gray, owner of Gray's Mills, around 1820. A wooden bridge connected the house to the mill on the opposite bank of the Patapsco River. Gray's daughter Elizabeth married John Pendleton Kennedy in 1829 and also lived at Patapsco. Kennedy was a prominent Baltimore attorney. (Courtesy of the Enoch Pratt Free Library.)

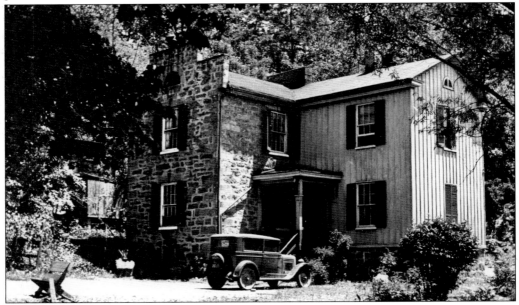

PATAPSCO, 1936. Patapsco suffered major damage during the flood of 1868. After the flood, the house was repaired and altered from its original construction. In 1917, the Gas and Electric Company acquired the property, and the house served as a caretaker's cottage. Today Patapsco is a private residence located near the intersection of Frederick and River Roads. (Courtesy of the Enoch Pratt Free Library.)

SPRING HILL. In 1787, a log hunting lodge was built on the site of Spring Hill by Charles and Rebecca Ridgely for use as a summer home. At the same time, the Ridgelys were building their grand home, Hampton Manor, in northern Baltimore County. The Ridgelys, having no children of their own, left their estate to nephew Charles Carnan Ridgely, Maryland governor from 1816 to 1819. It was Charles who expanded Spring Hill to its present size. Spring Hill passed to Mary Pue Ridgely, who married Samuel Worthington Dorsey. The house remained in Dorsey hands until 1910 with the death of Comfort Dorsey. Comfort's story is a sad one. Her beloved fiancé was killed in a hunting accident, and she never recovered from the loss. Owners since the Dorseys have reported that an apparition of a "gentleman in fine attire" has been seen roaming the halls—perhaps Comfort's long-lost love? At times, sounds of a lively party, including harpsichord music, can be heard coming from the parlor, but when the doors are opened, the sounds cease. Spring Hill remains a private residence at 4659 Montgomery Road. (Courtesy of the Howard County Historical Society.)

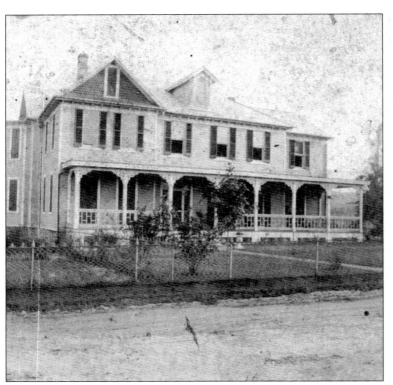

KRAFT-SLACK HOME. This house was home to Martin L. Kraft (born in 1871), son of Andrew Kraft, proprietor of the Kraft Meat Market on Main Street in Ellicott City. Martin attended Rock Hill College and upon graduation took over the family business. The house's outbuildings were where the Krafts did their butchering. (Courtesy of the Howard County Historical Society.)

ANNA L. KRAFT, WIFE OF MARTIN KRAFT, C. 1890. Martin Kraft could be seen daily delivering meat by horse and wagon on the streets of Ellicott City. Children would often congregate around Martin's delivery wagon, and he would pass links of sausage to them. Some of the children would later recall the sausages as being better than any modern-day hot dog. (Courtesy of the Howard County Historical Society.)

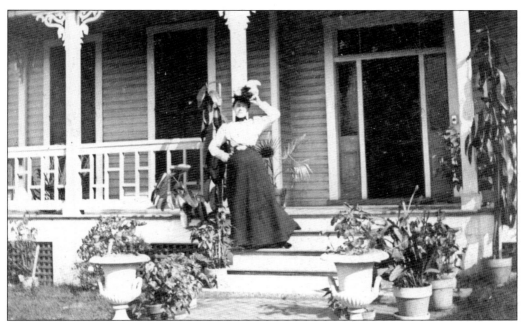

MARY JANE L. KRAFT, SISTER OF MARTIN KRAFT, SUMMER OF 1899. In 1939, the Kraft home's facade was greatly modified by Frank C. Higinbothom, who ran Higinbothom Funeral Home until 1967. Since that time, it has been home to the Slack Funeral Home, located at 3871 Old Columbia Pike. (Courtesy of the Howard County Historical Society.)

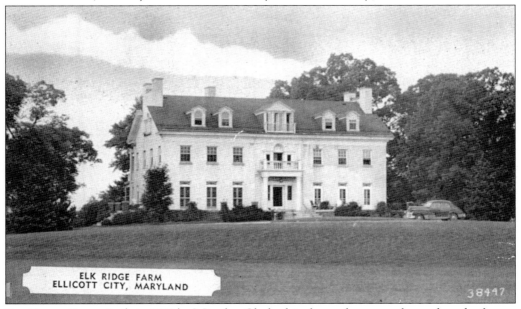

ELK RIDGE FARM
ELLICOTT CITY, MARYLAND

38497

ELK RIDGE FARM. Built in 1913 by J. Booker Clark, this elegant home was located on the former Cherry Lane (4200 block of Montgomery Road), the current site of the Long Gate Shopping Center. On July 2, 1920, a fire broke out. The complete loss of the home was due to a shortage of water caused by a large crack in the home's water tank. The tank stood in place until 1996, when it was removed to make room for a Target. (Courtesy of the Howard County Historical Society.)

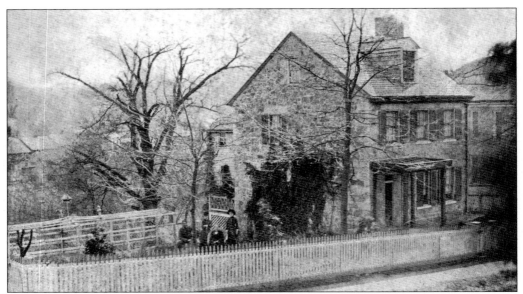

JONATHAN ELLICOTT–MACGILL HOUSE, 1881. This granite house, built in 1775 on Church Road, is believed to be the first home of Jonathan Ellicott, son of Andrew. By 1860, it belonged to Samuel Powell, who built an addition. In the mid-1880s, it became the home of Maria Gambrill Macgill. The home later passed to Marion and Nellie Dorsey Macgill. (Courtesy of the Howard County Historical Society.)

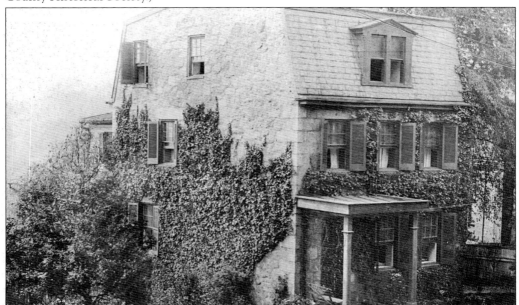

JONATHAN ELLICOTT–MACGILL HOUSE, C. 1900. Marion and Nellie Macgill expanded the third floor to accommodate their family. Compare the mansard roof of this photograph to the gabled roof of the photograph above. Grace Macgill, daughter of Marion and Nellie, sold the home in 1945 to Mr. and Mrs. J. Carroll Jenkins, one of the founders of the Commercial and Farmers Bank. The home continues to be used as a private residence. (Courtesy of the Howard County Historical Society.)

DR. ISAAC MARTIN HOME, C. 1915.
Dr. Isaac Martin built his home in 1872 on the corner of Church Road and Emory Street. Dr. Martin was a prominent pharmacist. He manufactured Oriental Tooth Wash "for cleaning and preserving teeth," as well as Elixir of Calisaya Bark for "weak stomachs and a pleasant, safe remedy for worms in children." Standing in the foreground is Julian Kinlein. (Courtesy of the Howard County Historical Society.)

BROXTON. The origins of Broxton are unknown, but architectural clues date the home to *c.* 1840. By 1878, it was the home of Mary Penny. The home boasts an elegant staircase with hand-turned curly maple spindles and a mahogany banister. The dining room's fireplace mantel is of black and white marble with pilasters of Roman arch design. This impressive home remains a private residence on over 17 acres at 3829 Old Columbia Pike. (Courtesy of William Hollifield.)

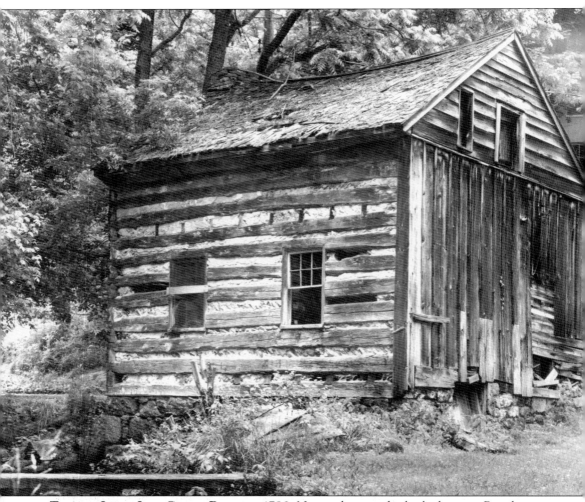

THOMAS ISAAC LOG CABIN, BUILT C. 1780. No one knows who built the post–Revolutionary War home. The cabin was built on land at the end of Merryman Street. Originally the cabin had one room upstairs and one room downstairs, with an attic and probably an outdoor kitchen and bathroom facilities. By 1878, the building had been enlarged to include additional first- and second-floor rooms. A later addition provided space for an attached kitchen. The log cabin was one of the Isaac family's three residences. After a flood, the Isaacs moved their cabin higher up the road to the top of a hill and out of the flood plain to protect themselves from future catastrophes. The cabin was dismantled in 1980, stored by the county at Centennial Park, and reassembled in 1987 on its new site at the corner of Main Street and Ellicott Mills Drive. Today it is the headquarters of the county's Ellicott City Historic Sites Consortium. (Courtesy of the Howard County Historical Society.)

Six

THE MERCHANTS

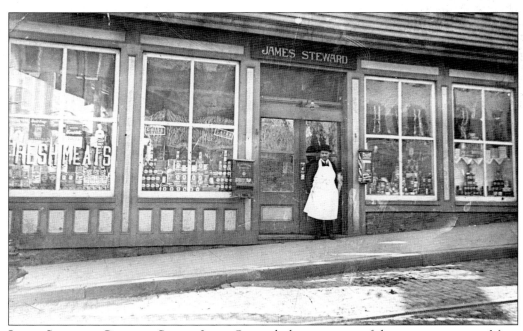

JAMES STEWARD GROCERY STORE. James Steward, the proprietor of this grocery store on Main Street, is posing for a picture postcard. No doubt the postcard was proudly sold in his store along with the fare of his trade. (Courtesy of the Howard County Historical Society.)

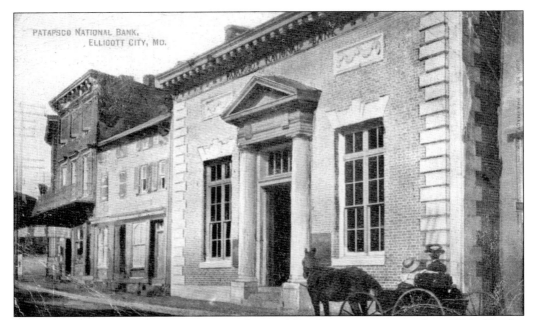

PATAPSCO NATIONAL BANK. Patapsco National Bank was incorporated in 1833. Charles Carroll of Carrollton, Charles W. Dorsey, Allen Thomas, Nicholas Worthington of John, Nathaniel H. Ellicott, Thomas Beale Dorsey, and Hugh Ely were named commissioners. Their task was to receive subscriptions of stock not to exceed an amount of $150,000. The first bank building, located at Maryland and St. Paul Streets, is now part of St. Paul's Church. (Courtesy of William Hollifield.)

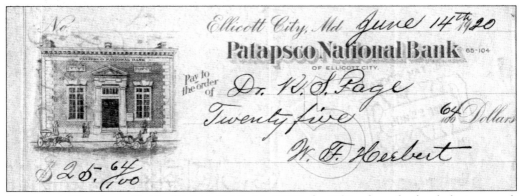

PATAPSCO NATIONAL BANK CHECK, JUNE 14, 1920. In 1833, when the bank first opened, Bernard U. Campbell was appointed cashier with an annual salary of $1,300, and clerk William B. Dorsey received $500 per year. In 1903, the bank purchased the site of a livery stable on Main Street and, in 1905, opened its new doors at 8098 Main Street. The bank later became the First National Bank until it closed its doors in the 1980s. (Courtesy of William Hollifield.)

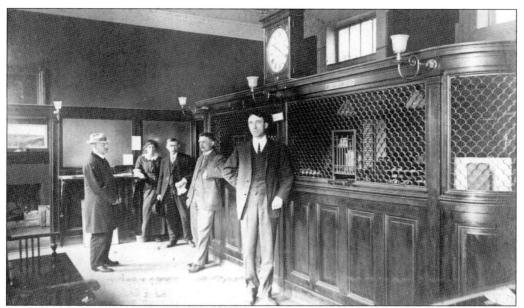

PATAPSCO NATIONAL BANK INTERIOR, C. 1900. On May 8, 1905, the *Ellicott City Times* reported: "One of the most attractive features of the building is the room set aside for ladies doing business with the bank. This has been fitted up in a very attractive manner with writing desks, stationery, chairs, etc., a fine old colonial fireplace and toilet room adjoining." The bench to the left can be seen at the Howard County Historical Society Museum. (Courtesy of the Howard County Historical Society.)

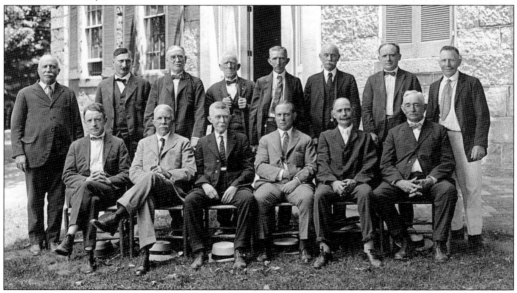

PATAPSCO NATIONAL BANK DIRECTORS IN FRONT OF COURTHOUSE, JUNE 25, 1923. Pictured from left to right are (first row) James Clark, Samuel S. Owings, John Collyer, Edward W. Talbot, Martin Kraft, and John L. Clark; (second row) Dan Gaither, Dr. Wilton Parlett, John S. Schrab, Mr. Hervey, Mr. Snyder, Mr. Musgrove, Arthur Pickett, and John Kraft. (Courtesy of the Howard County Historical Society.)

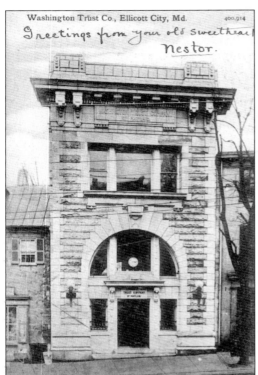

Washington Trust Co., Ellicott City, Md. 400,914

Greetings from your old sweetheart Nestor.

WASHINGTON TRUST COMPANY OF MARYLAND. In 1905, the Washington Trust Company of Maryland purchased property at 8137 Main Street and built this three-story bank building. In 1935, the bank reorganized as the Commercial and Farmers Bank; the bank occupied the building until 2002. (Courtesy of William Hollifield.)

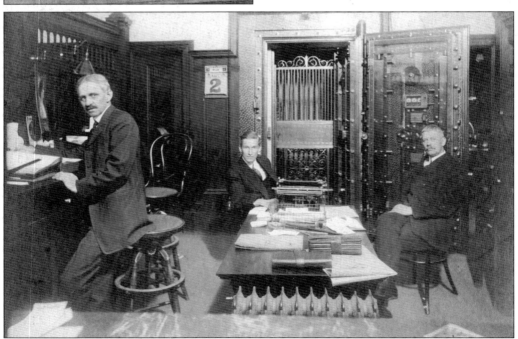

WASHINGTON TRUST COMPANY OF MARYLAND, INTERIOR, MARCH 2, 1911. Pictured from left to right are Carlton R. Sykes, Charles Werner Meade, and Louis Getz. The interior of the building has been greatly altered over the years. (Courtesy of the Howard County Historical Society.)

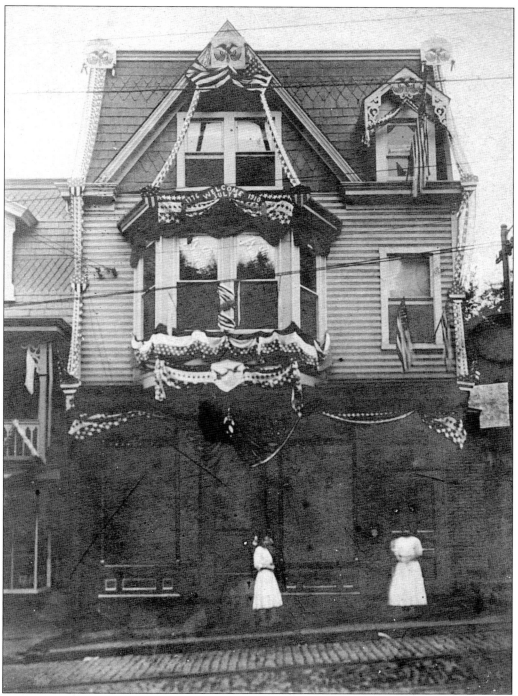

FOURTH OF JULY, 1910, DECORATIONS ON MAIN STREET. This building, located on the south side of Main Street near the intersection of Old Columbia Pike, is bedecked with red, white, and blue bunting. The banner reads "1776—Welcome July 4—1910." Perhaps the girls on the sidewalk are awaiting a parade. (Courtesy of the Howard County Historical Society.)

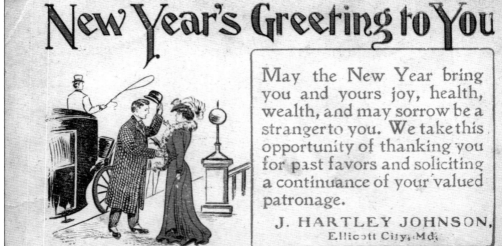

New Year's Greeting to You

May the New Year bring you and yours joy, health, wealth, and may sorrow be a stranger to you. We take this opportunity of thanking you for past favors and soliciting a continuance of your valued patronage.

J. HARTLEY JOHNSON,
Ellicott City, Md.

Putnam Fadeless Dyes color all kinds of goods at one time, fast, bright, beautiful colors, without staining the hands or spotting the kettle

J. HARTLEY JOHNSON'S NEW YEAR'S GREETING. The greeting reads: "May the New Year bring you and yours joy, health, wealth, and may sorrow be a stranger to you. We take this opportunity of thanking you for past favors and soliciting a continuance of your valued patronage." At the bottom is a promotion for "Putnam Fadeless Dyes color all kinds of goods at one time, fast, bright, beautiful colors, without staining the hand or spotting the kettle." (Courtesy of William Hollifield.)

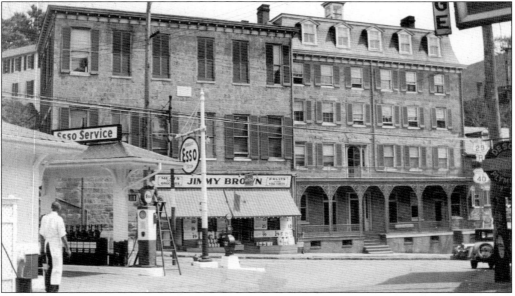

BUSINESSES ON MAIN STREET, C. 1936. On the left in the foreground is the Esso gas station at the junction of Columbia Pike and Frederick Road. The building on the left in the background is Jimmy Brown's grocery store. The building on the right with the ornate railings is the former Howard Hotel, built in 1840. Today the hotel has been converted into apartments. Residents have often reported sightings of apparitions, possibly former guests of the hotel. (Courtesy of the Enoch Pratt Free Library.)

Doughnut Machine Corporation Workers, October 8, 1930. The Doughnut Corporation of America was started in 1920 in New York City to sell automatic doughnut-making machines to bakeries. The machines operated in bakery windows from which people bought hot, freshly made doughnuts. These original machines made 480 doughnuts per hour. The company soon realized that it would have to make prepared mixes for bakers so they could produce doughnuts of a uniform standard, so the company took over the former Patapsco Flour Mills in Ellicott City. (Courtesy of William Hollifield.)

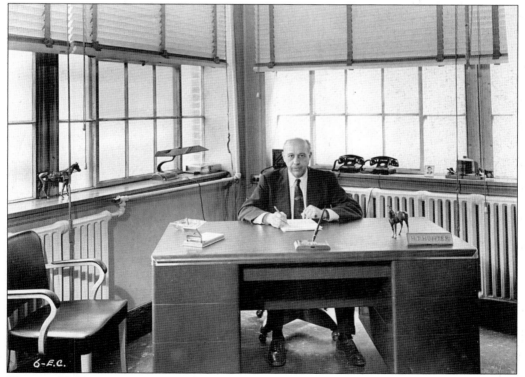

Herbert T. Hunter, c. 1945. Herbert T. Hunter managed the Ellicott City plant of the Doughnut Corporation of America. He was once called to testify before Congress. Apparently the American Red Cross, to which the company had donated truckloads of doughnuts daily during World War II, had charged GIs for the donated doughnuts. (Courtesy of Jacque and Gladys Tittsworth.)

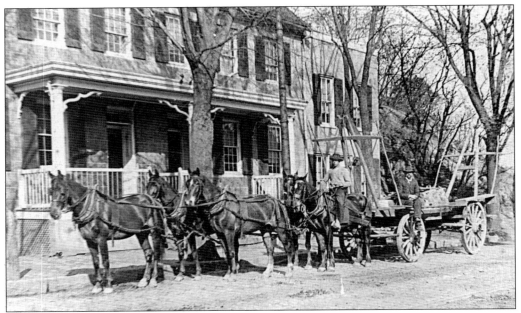

DISNEY'S TAVERN. The building, located at 8304 Main Street, is believed to date back as far as 1790 and was originally a private residence. It is known that in 1840, Deborah Disney opened a tavern at this address. The tavern also provided rooms to travelers. The building has since been divided in half. Gramp's Attic Books occupies the left side. Evidence of the tavern's dumbwaiter can still be found. (Courtesy of the Howard County Historical Society.)

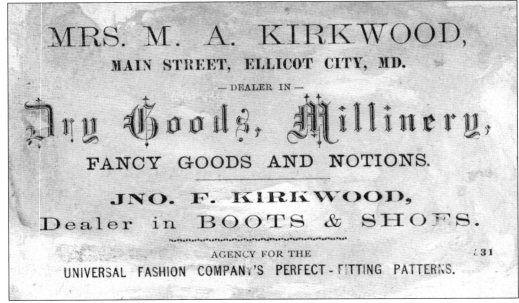

MRS. M. A. KIRKWOOD'S BUSINESS CARD. The card reads: "Mrs. M. A. Kirkwood, Main Street, Ellicott City, MD. Dealer in Dry Goods, Millinery, Fancy Goods and Notions. Jno. F. Kirkwood, Dealer in Boots & Shoes. Agency for the Universal Fashion Company's Perfect-Fitting Patterns." (Courtesy of William Hollifield.)

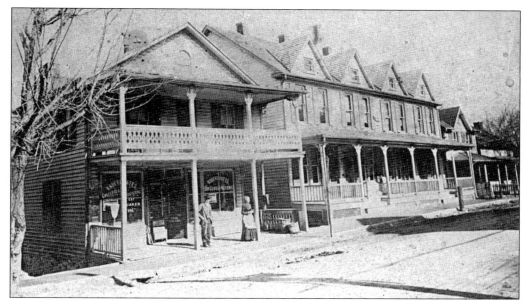

ROBERT G. YATES GENERAL STORE. Robert Yates moved to Ellicott City in 1870. He was elected mayor of Ellicott City in 1900 and reelected in 1904. In 1875, Robert had a nursery business at this location at 8548 Main Street. Later, as seen in this photograph, he ran a general store. Mr. and Mrs. Robert Yates are seen on the porch. The building is still standing and remains in the Yates family. (Courtesy of the Howard County Historical Society.)

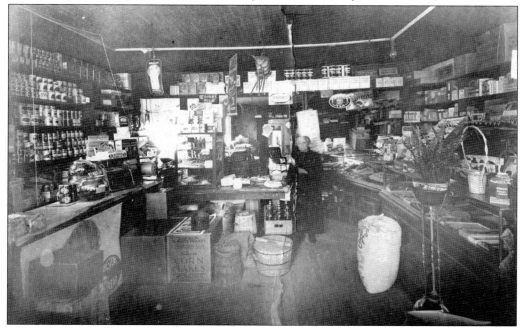

ROBERT G. YATES GENERAL STORE, INTERIOR. Mrs. Robert Yates is photographed standing amidst the well-stocked shelves of the general store. A 1909 article in *the Ellicott City Times* reported that in the general store "always can be found a choice collection of staple and fancy grocery." (Courtesy of the Howard County Historical Society.)

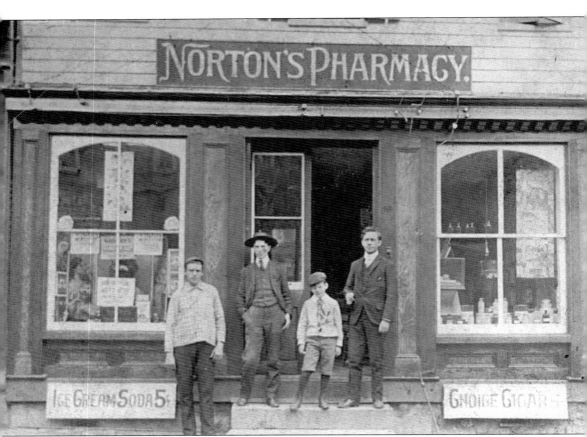

NORTON'S PHARMACY, C. 1909. Norton's Pharmacy was located at 8096 Main Street. The Romanesque building was originally built in 1886 by the Patapsco National Bank. The bank later built a new location next door and sold the building to Dr. John Joseph Norton in 1909. Norton's printed and sold many of the collectable postcards of Ellicott City that are still sought by collectors today. In 1917, Dr. Norton sold the building and moved his business to Laurel, Maryland. Pictured on the far right is Dr. John J. Norton, and second from left is his brother, Dr. Edward Norton, also a pharmacist. The other individuals are unidentified. (Courtesy of the Howard County Historical Society.)

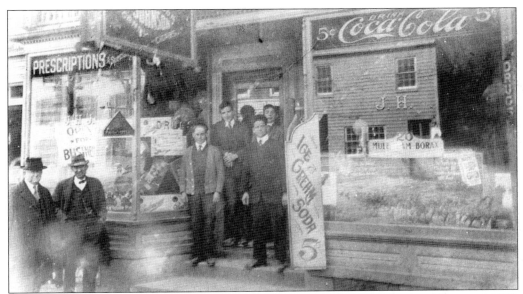

JOHNSON'S PHARMACY. J. Hartley Johnson owned Johnson's Pharmacy for over 15 years. A 1909 article in *the Ellicott City Times* described Johnson's: "The soda fountain is the handsomest in the city. The syrups dispensed are made of the purest fruit juices under the direct supervision of the proprietor." Pictured from left to right are (standing on street) Onley Wooton and Milton Hawking; (in doorway) Dr. Ben Mellor and three unidentified. Johnson's was located at 8169 Main Street. (Courtesy of the Howard County Historical Society.)

WILLIAM H. FISSELL'S GROCERY STORE, MAY 1936. In 1832, George Ellicott Jr. built a double stone house on Main Street. When his father deeded him the property, it was for the purpose of building a residence. In 1887, the left side of the building housed a carpet weaver, while the right side remained a residence. The house is pictured when it was occupied by the William H. Fissell Grocery Store. (Courtesy of the Howard County Historical Society.)

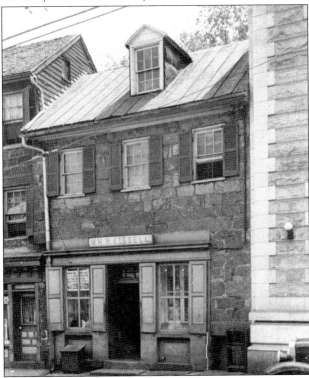

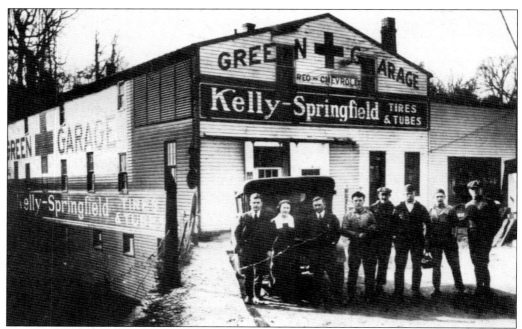

GREEN CROSS GARAGE, C. 1920. This was originally the Stephen Hillsinger and Sons Livery Stable, built over the Tiber River. One side of the building faced Hamilton Street, while the other faced Old Columbia Pike. The building burned to the ground in 1992. Pictured here from left to right are Charles Warfield, Irene Warfield, Melville Scott, B. H. Shipley, J. J. Bauman, James A. Ridgely, Samuel J. Yates Jr., and Guy D. Peddicord. (Courtesy of the Howard County Historical Society.)

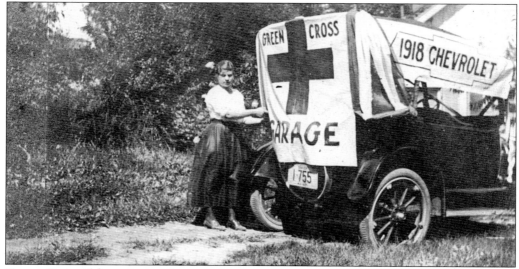

GREEN CROSS GARAGE, 1918 CHEVROLET. Automobiles needing repair were taken to the second floor of the garage by way of a ramp leading from the Old Columbia Pike side. If a car could not be driven, it was hoisted on a winch to the second-floor repair shop. It remained a Chevrolet dealership until 1936. The woman in the photograph is unidentified. (Courtesy of the Howard County Historical Society.)

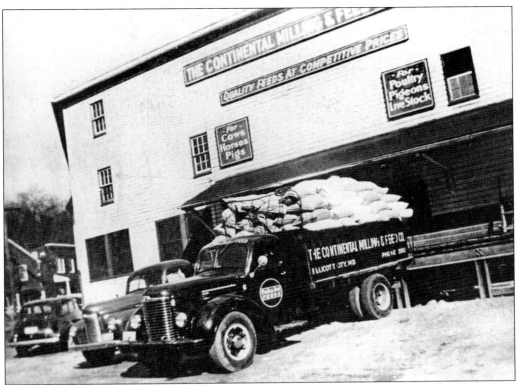

CONTINENTAL MILLING AND FEED COMPANY. The Continental Milling and Feed Company was located on the eastern side of the Patapsco River. The company used George Ellicott's house as its office. The feed company was later torn down to make room for a bypass road. (Courtesy of the Howard County Historical Society.)

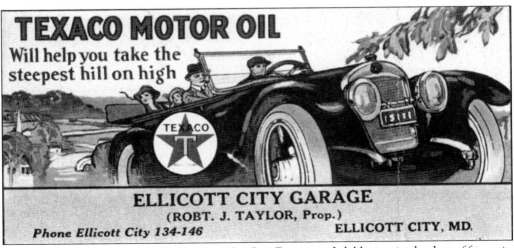

ELLICOTT CITY GARAGE TEXACO MOTOR OIL INK BLOTTER. Ink blotters in the days of fountain pens were often printed with advertising messages to be given away. This advertisement says, "Texaco Motor Oil will help you take the steepest hill on high. Ellicott City Garage (Robt. J. Taylor, Prop.) Phone Ellicott City 134-146. Ellicott City, MD." (Courtesy of William Hollifield.)

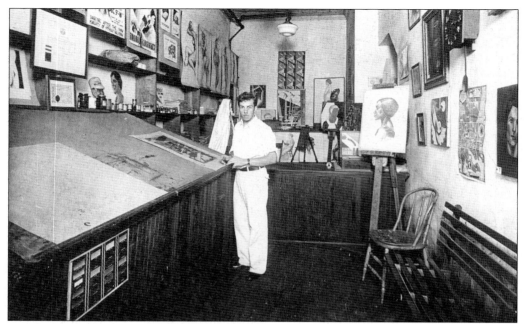

ARTIST CLAUDE TITTSWORTH. Claude Tittsworth's studio was located on Main Street opposite the B&O Railroad Station. His shop, simply called the Studio, produced many playbills for the Lyric Theatre in Baltimore, as well as advertising posters for Hutzler's department stores. (Courtesy of the Howard County Historical Society.)

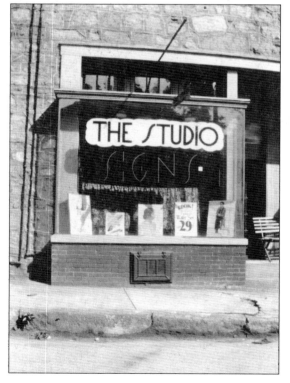

THE STUDIO. Artist Claude Tittsworth's business card stated: "Commercial Artist—On Main Street opposite B&O Station. Woodcuts—Costume Designs—Commercial Art—Posters—Portraits—Original Designs—Life Sketches—Water Color and Oil Scenery—Illustrations—Lettering." (Courtesy of the Howard County Historical Society.)

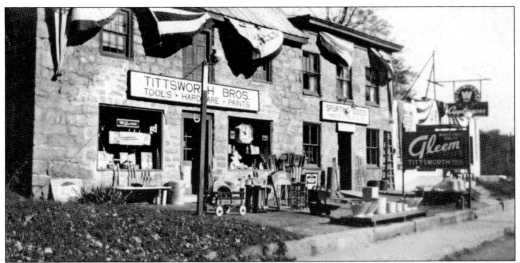

TITTSWORTH BROTHERS HARDWARE STORE, C. 1945. In the 1930s, Edyth Tittsworth's grocery store occupied this location. Edyth was known to welcome all children, white or African American, every day after school when they would come in to buy their afternoon sweets. The hardware store was owned by brothers Claude and Severn Tittsworth. Claude was also a commercial artist and had a studio on Main Street. (Courtesy of the Howard County Historical Society.)

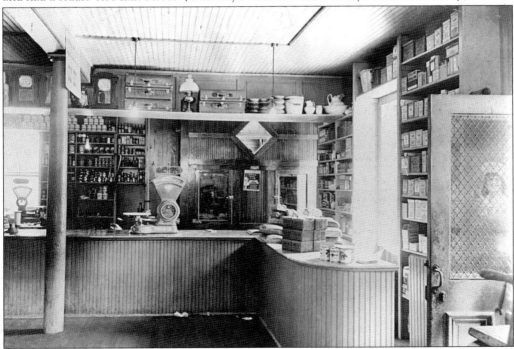

LEISHEAR'S GROCERY STORE. In the late 1880s, Joe Leishear ran a grocery store on Main Street. It was said of Joe, "He was of the old school, on-hand such thing as paper collars, etc., which he'd kept on his shelves for years. He would not tolerate paper bags and wrapped everything from pepper, salt, sugar, and flour in manila paper. His old colored man, Jake Henson, delivered heavy groceries on an old-fashion drag!" (Courtesy of the Howard County Historical Society.)

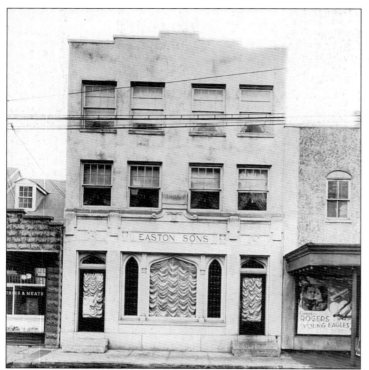

EASTON SONS FUNERAL HOME. Daniel Laumann and his son-in-law W. Clinton Easton purchased the Fort Undertaking business in the 1880s. William Fort was one of the first undertakers in Ellicott City, but his primary trade was that of cabinetmaker. During William Fort's time, when someone died, a family member would come in with a stick marked with the deceased's height and width for a coffin to be custom made. The building still stands at 8059 Main Street and is home to Bean Hollow Coffee Shop. (Courtesy of the Howard County Historical Society.)

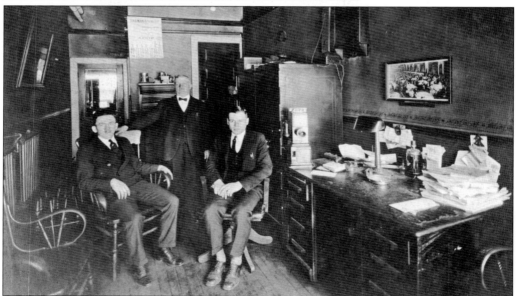

EASTON SONS FUNERAL HOME, BACK OFFICE, APRIL 1927. Pictured from left to right are Clinton M. Easton, Milton H. Easton, and Charles Debosier Sr. Besides the office, the first floor also housed a chapel that could seat 100 people. Milton's granddaughter, Jeanne Coffey, remembers her grandfather always having candy in his pocket for children he met in the course of a day. He would greet everyone he passed on the street with a tip of his hat and a friendly, "How 'do!" (Courtesy of the Howard County Historical Society.)

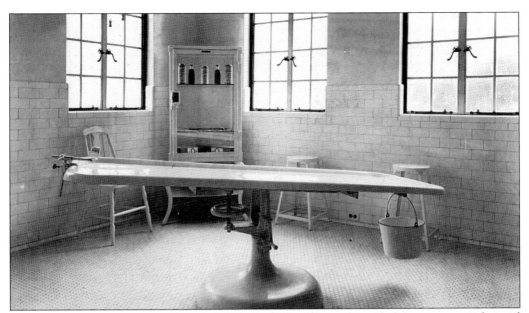

EASTON SONS FUNERAL HOME, EMBALMING ROOM, 1920S. The embalming room was located at the rear of the second floor. Also on the second floor were the visiting room and repose room. The repose room was for mourners who found themselves overcome with grief. The room had a small bed with an orchid cover, purple carpet on the floor, and smelling salts at the ready. (Courtesy of the Howard County Historical Society.)

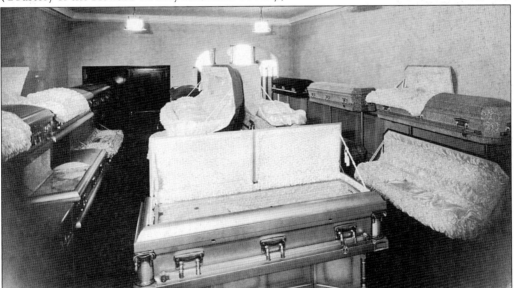

EASTON SONS FUNERAL HOME, CASKET SHOWROOM, 1920S. Located on the first floor, the showroom was entered through dark blue curtains. The doors in the rear left-hand corner were to an elevator that could also be entered from the alley on the opposite side. The elevator would transport the deceased to the morgue a floor above. On the landing to the second floor was a grandfather clock that is still in the possession of Easton's granddaughter, Jeanne Coffey. (Courtesy of the Howard County Historical Society.)

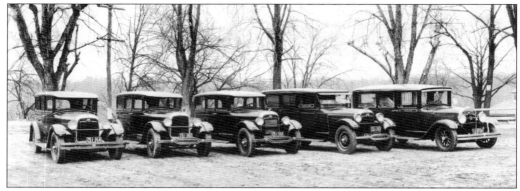

EASTON SONS FUNERAL HOME, FLEET OF VEHICLES, 1926. Easton Sons not only provided funeral services but ambulance services as well. They would transport the infirm to area hospitals and convalescence facilities. Compare the car on the far right to the one next to it. The far right car has a sign in the window that says "Invalid Coach." It has ornate windows, and a stretcher in the upright position can be seen. The car to its left has a sign that says "Funeral Coach," and the windows are plain. (Courtesy of the Howard County Historical Society.)

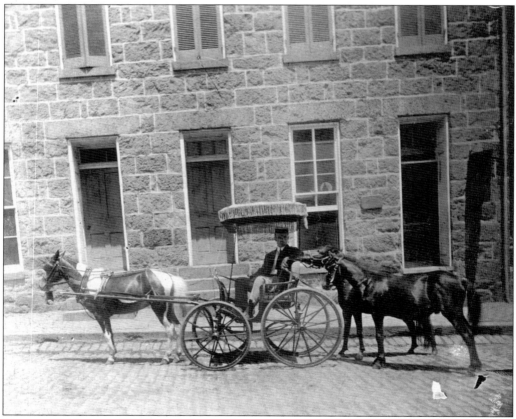

MILTON H. EASTON. The Easton family also ran a livery stable in Ellicott City. Milton is seen here in his surrey with a fringe on top being pulled by his prize-winning horse, Babylon. (Courtesy of the Howard County Historical Society.)

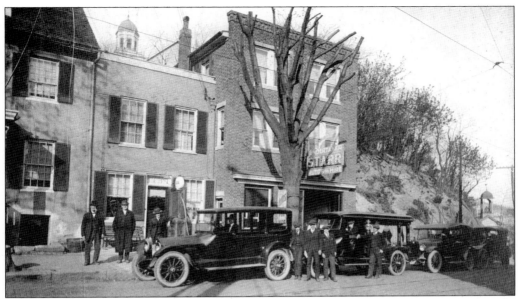

SCOTT M. STARR, EMBALMER, C. 1923. In 1919, Scott Starr purchased a frame print shop for use as a funeral home. A brick addition was built, and the frame building was renovated. The funeral home was located across the street from the current post office. Later the building would be divided into apartments. Pictured from left to right on the sidewalk are Steve Hillsinger, John Lyons, and Scott Starr. The other individuals are unidentified. (Courtesy of the Howard County Historical Society.)

SCOTT M. STARR CARS FOR HIRE. Adjacent to his funeral home, Scott Starr provided touring cars and limousine services. (Courtesy of the Howard County Historical Society.)

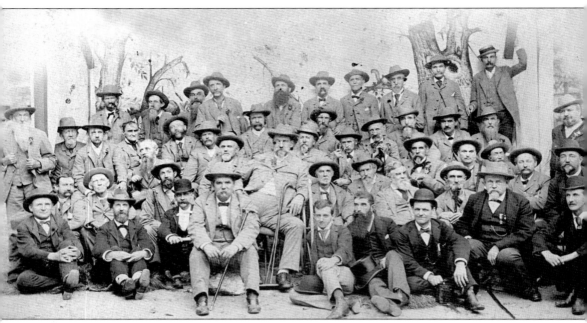

ELLICOTT CITY BUSINESSMEN, C. 1880. Pictured here are many of Ellicott City's businessmen. Note the trees in the background. They are part of a studio background and not real. There were too many men to group in front of the backdrop, and the real outdoors can be seen on the right edge of the photograph. (Courtesy of the Howard County Historical Society.)

Seven

THE PUBLIC SERVANTS

TROLLEY SERVICE TO ELLICOTT CITY. Trolley service was first proposed in Ellicott City in 1892 but did not become a reality until 1899. The solid granite along the river that needed to be removed for the trolley proved to be more stubborn than originally thought. The granite had to be blasted with dynamite repeatedly, and due to the expense, the construction was halted for a time. The trolley went as far as Ellicott City Mills Drive, where it turned around next to the old firehouse. (Courtesy of Scott Trapnell Hilleary.)

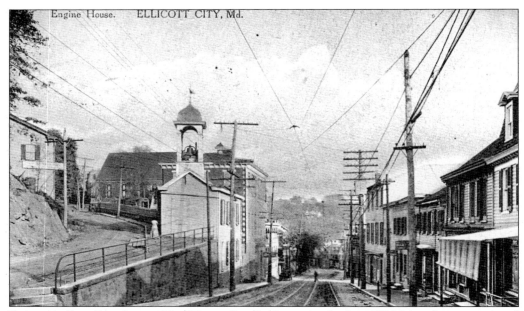

ELLICOTT CITY FIREHOUSE. The Ellicott City Firehouse was built in 1896. Many have questioned the logic of its precarious perch at the corner of Main Street and Church Street (then Ellicott Street). In 1896, Ellicott City did not have an engine to fight fires; instead, it had a bucket brigade. Thus the firehouse did not house a fire truck; rather, it was home to leather buckets, ropes, and ladders. (Courtesy of William Hollifield.)

ELLICOTT CITY FIREHOUSE, C. 1910. In 1888, the Ellicott City Fire Company acquired a Howe man-powered pumper, mounted on wheels. In 1894, a fire bell was donated by the B&O Railroad, and the cupola seen here was built to house it. The bell was rung to summon the members of the fire company. (Courtesy of the Howard County Historical Society.)

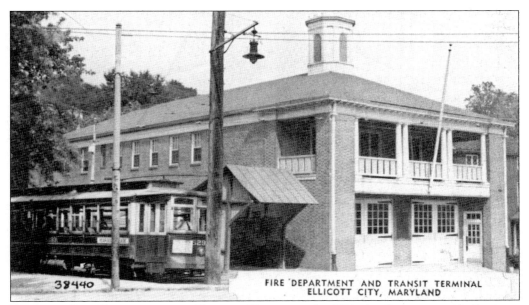

FIRE DEPARTMENT AND TRANSIT TERMINAL
ELLICOTT CITY, MARYLAND

ELLICOTT CITY FIREHOUSE AND TRANSIT TERMINAL. In 1924, the fire company built a new firehouse at 8390 Main Street to accommodate a new engine. The horse-drawn gasoline-fueled pumper that replaced the man-powered pumper was completely demolished after capsizing. The Regency Gallery currently occupies the former firehouse. (Courtesy of William Hollifield.)

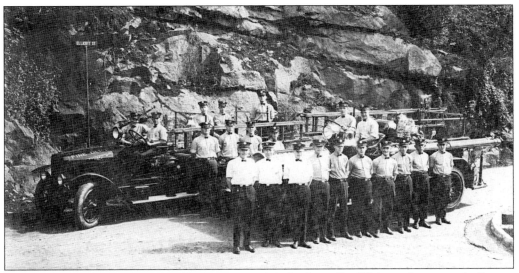

ELLICOTT CITY FIREMEN WITH ENGINE, C. 1924. On June 10, 1924, an American LaFrance triple combination engine was purchased for $10,500. With the new engine came a new name. The Volunteer Firemen of Howard County became incorporated and were named the Howard County Volunteer Firemen's Association. This photograph shows the engine parked at the end of Ellicott Street (now Church Street) just past the original firehouse. (Courtesy of Jacque and Gladys Tittsworth.)

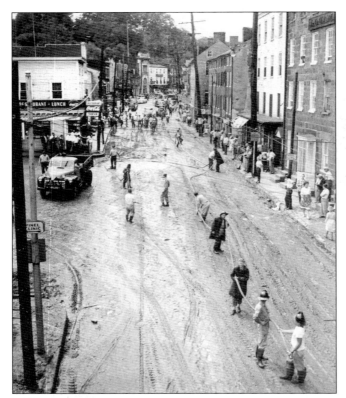

FLOOD OF 1953. Ellicott City has had its fair share of flooding. Devastating floods have been recorded as early as 1868, when the Patapsco River rose five feet in 10 minutes, leaving 36 dead and almost $1 million in damage. In 1953, the Tiber River overflowed during a heavy rainstorm. After the waters receded, mud from the Tiber covered Ellicott City. The fire department is seen cleaning up after the 1953 flood. (Courtesy of the Howard County Historical Society.)

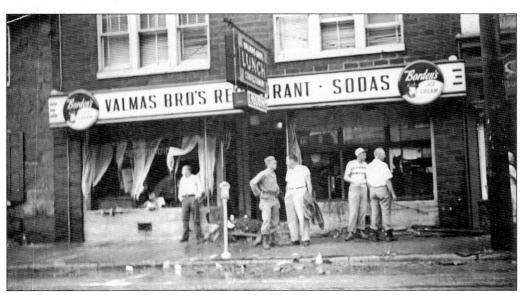

FLOOD CLEANUP. Ellicott City had much to clean up after the Tiber River deposited its mud. In this photograph, Valmas Brothers Restaurant, located on Main Street and owned by Paul Valmas, is shown during cleanup after the 1953 flood. (Courtesy of the Catonsville Room, Baltimore County Public Library.)

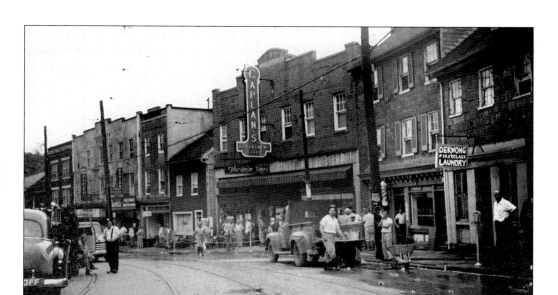

MAIN STREET FLOOD CLEANUP. This photograph shows the group effort of Main Street merchants in trying to rid their street of mud. David's Jewelers, Caplan's Department Store, and Derwong Laundry can be seen. (Courtesy of the Enoch Pratt Free Library.)

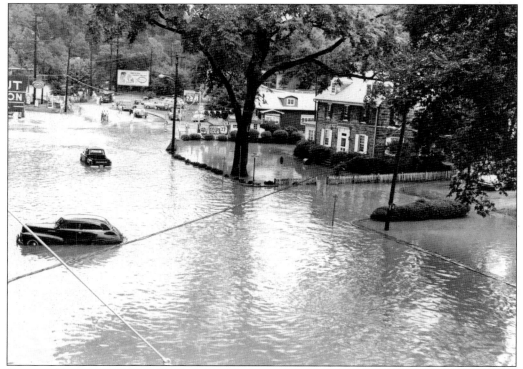

GEORGE ELLICOTT'S HOUSE UNDER WATER. George Ellicott's house can be seen in the upper right-hand corner. After the flood that followed Hurricane Agnes in 1972, the Ellicott house was moved across the street to preserve it as the only standing home of the Ellicott brothers. (Courtesy of the Howard County Historical Society.)

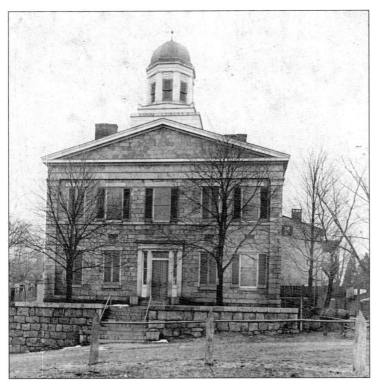

HOWARD COUNTY COURTHOUSE. On October 6, 1840, a site on Capitoline Hill was selected as the site of the Howard District of Anne Arundel County's courthouse. The site high above Main Street was selected because it would put the courthouse above the grunts and smells of livestock being driven to market. (Courtesy of the Howard County Historical Society.)

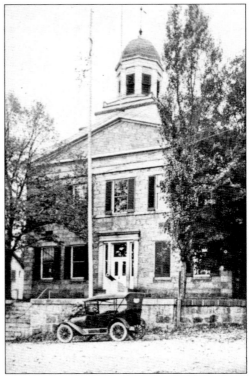

HOWARD COUNTY COURTHOUSE. Charles Timanus was the architect and builder of the Classical Revival building. The courthouse was completed in 1843 after taking over two years to build due to the extremely difficult task of hauling granite and lumber up the steep hill. The cannon in front of the courthouse is said to have been captured by John Dorsey at the Battle of Bladensburg during the War of 1812. (Courtesy of William Hollifield.)

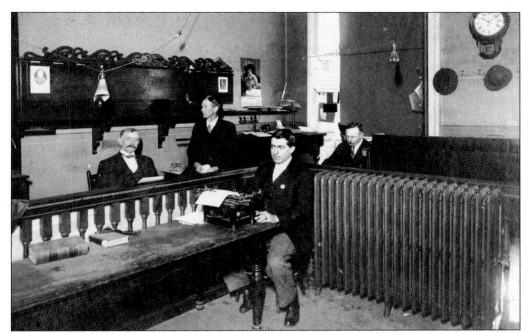

HOWARD COUNTY COURTHOUSE EMPLOYEES, C. 1904. Pictured from left to right are Richard Davis, Mortimer Crapster, Jim Clark Sr., and ? Mann. (Courtesy of the Howard County Historical Society.)

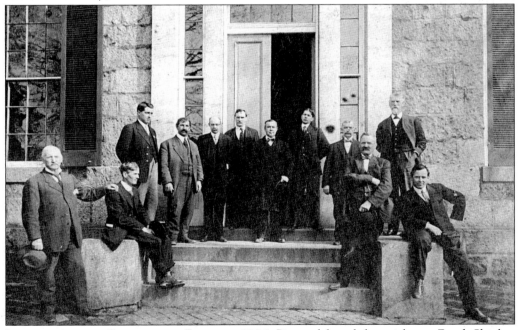

LAWYERS ON THE COURTHOUSE STEPS, C. 1904. Pictured from left to right are Frank Shipley, William Dominic Donovan, unidentified, Thomas Boston, M. J. Sullivan, Edward Jones, ? Easton, John Dempster, Richard Davis, William Mahon, ex-judge ? McCafferty, and Joseph Donovan. (Courtesy of Jim Hooper.)

ELLICOTT CITY JAIL, C. 1915. Built in 1878 and named Willow Grove because of the surrounding landscape, the Romanesque Revival building was made of stone and contained eight cells. Under the front gable, cut into stone, are the names of the county commissioners in 1878: Samuel Brown, Jerome C. Berry, and William Rowles. Executions took place at Willow Grove as late as 1916. In 1984, the jail moved to the Jessup facility. The jail still stands at 1 Emory Street and is used for storage for the courthouse; it is greatly in need of repair. (Courtesy of the Howard County Historical Society.)

ELLICOTT CITY'S FIRST JAIL, C. 1939. Prior to the construction of the more secure facility at Willow Grove, this building on Fells Lane served as Ellicott City's jail. The basement appeared to have been the lock-up. It has very thick masonry walls and small barred windows. The building is seen here when it was used as a residence in the 1930s. The original clapboard siding was covered in cedar shingle. (Courtesy of the Enoch Pratt Free Library.)

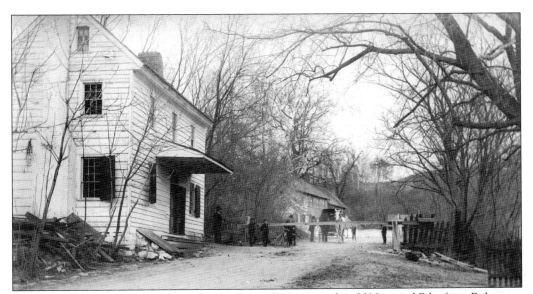

TOLLGATE EAST OF THE PATAPSCO RIVER. The tollgate is on the old National Pike from Baltimore to Cumberland, Maryland. The Baltimore-Fredericktown Turnpike Company was franchised by the state in 1805 to construct, maintain, and collect tolls on 62 miles of toll road from Baltimore to Boonesboro, Maryland. (Courtesy of the Enoch Pratt Free Library.)

TOLLGATE WEST OF ELLICOTT CITY, MAY 3, 1908. The first tollgate was opened in April 1807. Jonathan Ellicott, president of Baltimore-Fredericktown Turnpike Company, was instrumental in having three other turnpikes formed. The road extended over the mountains to Cumberland, where it met the federally funded National Road, which opened in 1818. A group of banks, mostly from Baltimore, provided the capital for the construction. (Courtesy of the Catonsville Room, Baltimore County Public Library.)

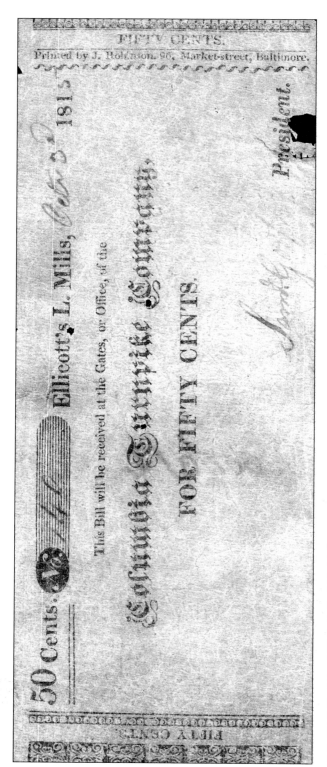

COLUMBIA TURNPIKE COMPANY NOTE, 1815. This piece of ephemera has survived 191 years and is a rare find. The bill, or receipt, shows payment of 50¢ to use the turnpike road. Printed on the note is "50 cents—No. 140—Ellicott's L. Mills, October 30, 1815. This Bill will be received at the Gates, or Office of the Columbia Turnpike Company. For Fifty Cents.—Printed by J. Robinson 96, Market-street, Baltimore." Disappointingly the president's signature cannot be made out. (Courtesy of William Hollifield.)

Eight

THE FACES AND PLACES

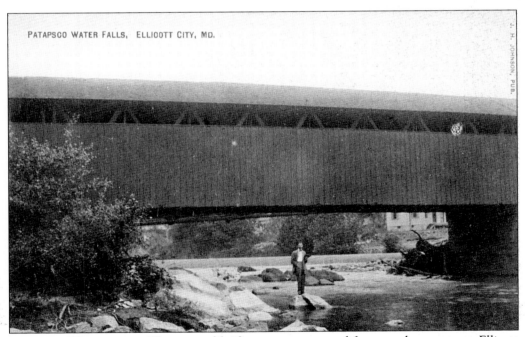

PATAPSCO WATER FALLS, ELLICOTT CITY, MD.

PATAPSCO WATERFALLS. The covered bridge gave wagons and foot travelers access to Ellicott City from the eastern shore of the Patapsco River. In 1850, after complaints of churchgoers, cattle were banned on the bridge on Sunday mornings. The covered bridge burned on June 7, 1914, and was replaced with a concrete bridge. (Courtesy of William Hollifield.)

THE FOREST RESERVES CAR. The patrol car pictured is a 1926 Chevrolet. It was operated in the late 1920s by Edwin George Prince, the first park ranger in the state. He served the Patapsco State Park Rangers. Edwin is in the driver's seat, and another state forester, Karl Pfeiffer, can be seen in the back holding a backfire torch, which was the type used in those days. (Courtesy of the Catonsville Room, Baltimore County Public Library.)

PATAPSCO STATE FOREST, JULY 1924. The women in this photograph are enjoying a July afternoon at the Cascade Branch in the Patapsco State Park. (Courtesy of the Enoch Pratt Free Library.)

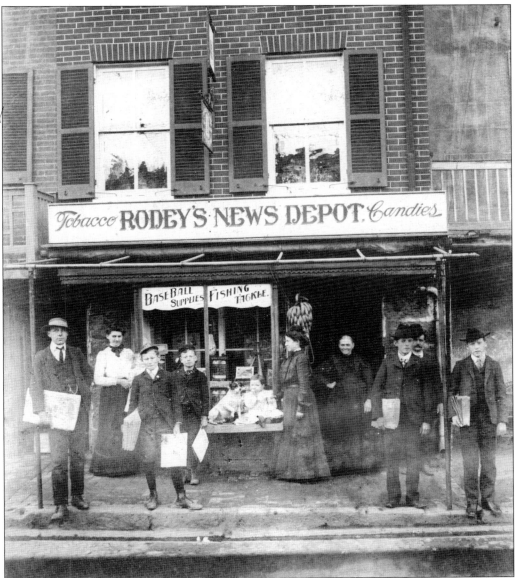

RODEY'S NEWS DEPOT, C. 1900. In 1898, Edward A. Rodey opened Rodey's News Depot, located at 8048 Main Street. For years, he held the agency for newspaper distribution from Baltimore to Ellicott City. He was postmaster during both of the administrations of Woodrow Wilson. In 1924, when Stephen W. Gambrill was elected to Congress, he made Rodey his first secretary. Edward did not like Washington life and resigned after two years of service. In 1909, he was made a magistrate by Gov. Edwin Warfield. Edward died of a heart attack at the age of 74 in front of the post office he once ran. In 1909, *the Ellicott City Times* reported: "The news depot always reflects the literary development of a community and judging from the large collection of magazines, and current literature covering a wide range of subject matter found in the establishment of Edward A. Rodey, this literary development in Ellicott City is both pronounced and commendable." Pictured at far left is Edward Rodey and third from left is Charles Werner Meade. The other individuals are unidentified. (Courtesy of the Howard County Historical Society.)

THE GODDESS. The movie *The Goddess* was filmed in Ellicott City in 1957. Columbia Pictures chose Ellicott City as the film's setting because of its timelessness. The movie's leading lady was actress Kim Stanley, seen here with local resident Lloyd Taylor. Lloyd's one line in the movie was, "You goin' to buy anything or are you goin' to stand there blocking the door?" Taylor's copy of the script was given to the Howard County Historical Society. (Courtesy of the Howard County Historical Society.)

THE GODDESS. Many Ellicott City residents worked as extras in the film and were paid $12 a day. John Slack, funeral director of Slack Funeral Home, appeared, unsurprisingly, as an undertaker. The movie's story was set in 1930. It starred Lloyd Bridges, Steven Hill, Betty Lou Holland, Kim Stanley, and Burt Brinckerhoff. The screenplay was written by Paddy Chayefsky, and it was directed by John Cromwell. (Courtesy of the Howard County Historical Society.)

THE GODDESS. Kim Stanley plays a neglected young woman living in poverty who aspires to be a movie star. She gets a few roles here and there on her looks alone. She marries a washed-up athlete (Lloyd Bridges) who becomes fiercely jealous of her sex appeal. She sleeps her way to the top, and then finds that her success is hollow. It was believed at the time that the story was loosely based on Marilyn Monroe's life, although those involved denied it. (Courtesy of the Howard County Historical Society.)

THE GODDESS. *The Goddess* was nominated for an Oscar for best screenplay in 1958. While the theme may seem trite today, at the time, Chayefsky hit a nerve in Hollywood, and the film became notorious. The critics loved the movie, and it was advertised: "Hollywood Hates This Movie . . . But They can't deny it's true!" (Courtesy of the Howard County Historical Society.)

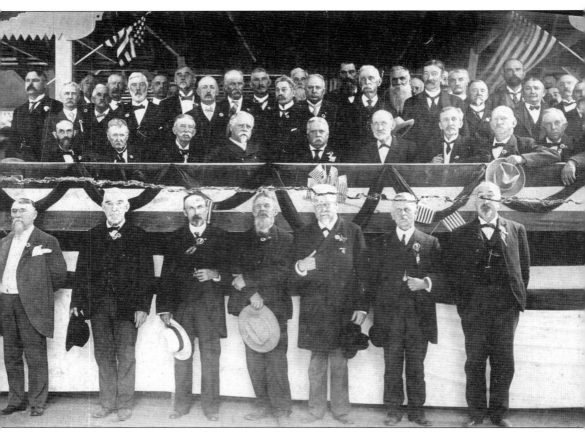

REUNION OF CONFEDERATE VETERANS. Ellicott City resident William Forsythe can partially be seen in the top row, standing at far right with white hair. Ellicott's Mills was very active during the Civil War. The B&O Railroad and the National Road, which ran through the middle of Ellicott's Mills, transported goods for both sides. The railroad and its bridges became prime targets of the Confederate army. A contingent of Union soldiers was stationed strategically in the Elkridge area to guard the Thomas Viaduct. The famous Raid of Ellicott's Mills took place when Union soldiers discovered that a "secret weapon," a Winans steam gun, was being smuggled from Ellicott's Mills to Rebel soldiers. The Winans steam gun was capable of firing up to 500 rounds per minute without reloading. Had the steam gun reached Confederate lines, and had the gun been the mechanical success claimed by the inventor, it conceivably could have altered history and probably would have become as famous as the *Monitor* and *Merrimac*. The capture by the Yankees and their inability to figure out how it worked, however, prevented this. (Courtesy of the Howard County Historical Society.)

GIRL ON BRIDGE OVERLOOKING THE PATAPSCO RIVER. This image appeared on a postcard. The date of July 4 was written on the front. The unidentified girl sits on the handrail of the covered bridge that spanned the Patapsco River. Angelo Cottage can be seen on its regal perch above the river. Everyone the author has shown this picture to immediately fell in love with the image. She seems to have some kind of magical hold on all who see her innocent smile. Perhaps one day, someone can identify her and tell her story. (Courtesy of William Hollifield.)

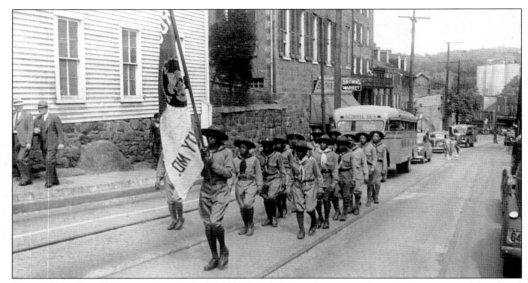

MEMORIAL DAY PARADE, JUNE 28, 1943. This African American Boy Scout troop, with school bus following, proudly marches up Main Street during the 1943 Memorial Day Parade. (Courtesy of the Howard County Historical Society.)

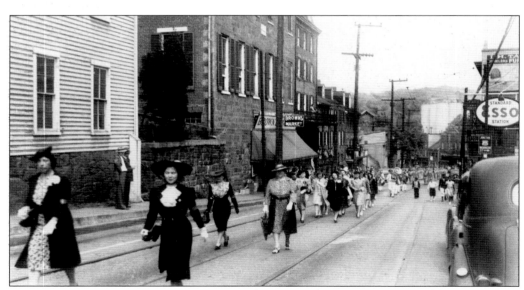

MEMORIAL DAY PARADE, JUNE 28, 1943. This group of women, possibly Gold Star Mothers, had their work cut out for them when they trekked uphill on Main Street in their good shoes. For reason unknown, the annual Memorial Day Parade was marched uphill rather than a less physically taxing downhill route. (Courtesy of the Howard County Historical Society.)

HARDMAN'S BEAUTY REST COTTAGES — *Alternate Route 40* — NEAR ELLICOTT CITY, MARYLAND

HARDMAN'S BEAUTY REST COTTAGES. This card advertises "Hardman's Beauty Rest Cottages—Alternate Route 40—Near Ellicott City, Maryland—Hardman's Edmondson Avenue Extended. Corner of St. John's Lane, 12 mi. West of Baltimore. 16 new Beauty Rest Cottages—Maple Furniture—Hot Water Heat—Tile Showers." Hardman's played a minor role in the World War II efforts. German prisoners of war were bused from Fort Meade into Howard County to help harvest county crops. The POWs were taken to Hardman's, where area farmers would pick them up. The prisoners were paid 80¢ a day. (Courtesy of the author's collection.)

RACHEL GIST SYKES UNDER CHRISTMAS TREE, C. 1901. Rachel Gist Sykes (1893–1918) had a truly Victorian Christmas morning. Rachel was the youngest daughter of Mordecai Gist Sykes, who was the first elected mayor of Ellicott City and served two terms from 1889 to 1897. Mordecai was born in Ellicott's Mills in 1860, the son of Sylvanus Sykes (who died in 1872). Sylvanus was a dentist, and Mordecai followed in his footsteps. Mordecai was educated locally at Rock Hill College. He graduated from the Baltimore College of Dental Surgery in 1882. In 1884, he married

Mollie A. Gaither, also of Ellicott City, and together they had three children; Gaither, Hannah, and Rachel. Mordecai set up practice in the office of his father at 8293 Main Street. The Sykes family lived above the dentist office. Rachel is seen here in the family's front parlor on the second floor. Today the building is home to Tersiguel's French Country Restaurant. (Courtesy of the Howard County Historical Society.)

RACHEL GIST SYKES, 1915. Rachel Gist Sykes is attired in a period costume for a "Martha Washington Tea," a benefit sponsored by the First Presbyterian Church. (Courtesy of the Howard County Historical Society.)

SYKES CHILDREN, C. 1903. Pictured from left to right are Rachel Gist Sykes, Hanna Isabel Sykes, and Gaither Hunter Sykes. The Sykeses were visiting the Sunderland home on Fells Lane. (Courtesy of the Howard County Historical Society.)

GAITHER HUNTER SYKES, C. 1903. Gaither Hunter Sykes, son of Ellicott City's dentist and mayor, is seen here in his Virginia Military Institute uniform. He and his canine companion are standing outside the Sunderland home on Fells Lane. (Courtesy of the Howard County Historical Society.)

MARIE BARTON BECK, OCTOBER 18, 1916. Marie Barton Beck is photographed in her bridesmaid's dress and laden with roses as an attendant to her future sister-in-law, Hannah Isabel Sykes. Marie would later marry Gaither Hunter Sykes. (Courtesy of the Howard County Historical Society.)

CARROLL WOMEN, 1934. Pictured here from left to right are Suzanne Bancroft Carroll and her daughters, Mary Lee Carroll Muth and Helen Carroll Wright. Suzanne was married to Charles Carroll, great-grandson of Charles Carroll of Carrollton, owner of Doughoregan Manor, in 1934. Helen Carroll Wright died in 1996 at the age of 84. Like her great-great-grandfather, the signer of the Declaration of Independence, she enjoyed a long life. (Courtesy of the Howard County Historical Society.)

ALBERT HENRY CARROLL. The dapper young Albert Henry Carroll was the great-great-grandson of Charles Carroll of Carrollton and son of John Lee Carroll (1830–1911), governor of Maryland from 1876 to 1880. Albert died in 1910 of twisted intestines. The equestrian life was commonplace at Doughoregan Manor. In the late 19th century, jousting contests were held at the manor. Later there was an annual horse show whose proceeds went to charity. (Courtesy of the Howard County Historical Society.)

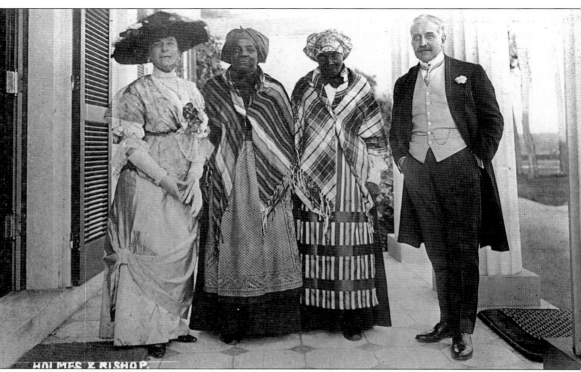

HOLMES & BISHOP.

MR. AND MRS. CHARLES CARROLL AND SERVANTS, 1914. Charles Carroll and his wife, Suzanne Bancroft Carroll, held a large celebration in honor of their 25th wedding anniversary at their Doughoregan Manor home in 1914. No one was left out of the celebration. In this photograph, the Carrolls are seen with two of their servants. Pictured from left to right are Suzanne Bancroft Carroll, Caroline Joyce (Joice), Maggie ?, and Charles Carroll. (Courtesy of the Howard County Historical Society.)

CAROLINE JOYCE (JOICE). Caroline Joyce (sometimes spelled Joice) worked at Doughoregan Manor as a servant. She is believed to be a descendant of the African American Joices who had worked at Doughoregan Manor for generations. The first Joice came to Doughoregan Manor as a slave owned by Charles Carroll of Carrollton, signer of the Declaration of Independence. (Courtesy of the Howard County Historical Society.)

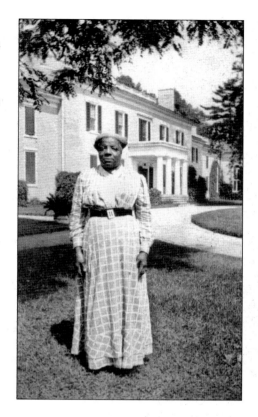

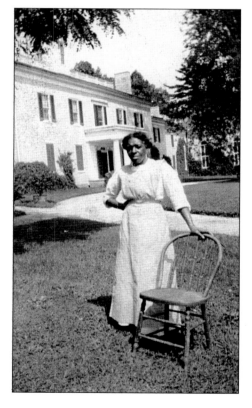

MAGGIE. Maggie (last name unknown) worked at Doughoregan Manor as a servant. (Courtesy of the Howard County Historical Society.)

NANNY AT FONT HILL, C. 1880. The African American woman in this photograph, believed to be Emma Jones, worked for the Fort family at Font Hill. Dr. Samuel Jayne Fort (1859–1925) ran a home for "feeble-minded individuals." It was the first institution of its kind south of the Mason-Dixon Line. The baby's name is unknown. (Courtesy of Alice Fort.)

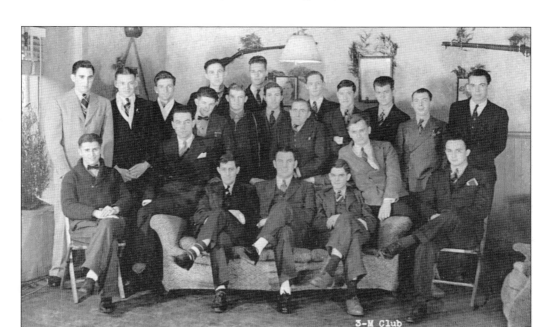

ELLICOTT CITY 3-M CLUB, NEW YEAR'S DAY, 1940. The 3-M Club began in 1926, but the premise of the organization is unknown. It may have been a shooting club. Claude Tittsworth, commercial artist and local merchant, is seen in the center of the photograph in the second row. Over his left shoulder is a photograph of him, hanging on the wall. He served as president of the club in 1937. Claude played the banjo at club gatherings. (Courtesy of the Howard County Historical Society.)

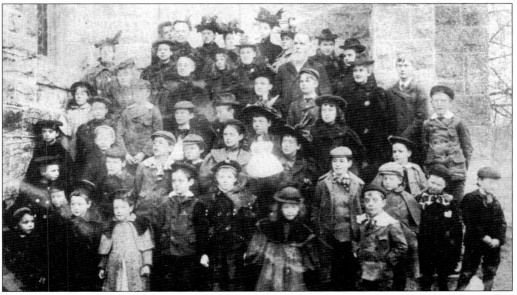

FIRST PRESBYTERIAN CHURCH SUNDAY SCHOOL CLASS. Rev. Henry Branch can be seen in this photograph (the man with a beard in the center of the back row) with Sunday school students and their teachers. First Presbyterian Church is now home to the Howard County Historical Society on Court Avenue. Note the little girl in the center proudly holding up her doll to be photographed. (Courtesy of the Howard County Historical Society.)

TROLLEY ACCIDENT, 1906. This trolley derailed and collided with a telephone pole. The unfortunate incident was a source of entertainment to onlookers both from the curb and from above on the train bridge. Note the blur of what, at first glance, seems to be three young boys. The blur is of the same active boy captured in three different spots, as the camera took a long time to capture the image. (Courtesy of the Howard County Historical Society.)

B&O Railroad Depot. Completed by the B&O Railroad in 1830, Ellicott City Station is the oldest surviving railroad station in America and the site of the original terminus of the first 13 miles of commercial track ever constructed in America. In the 1970s, the station was restored as a museum, and a second restoration in 1999 returned the building to its 1857 appearance. (Courtesy of William Hollifield.)

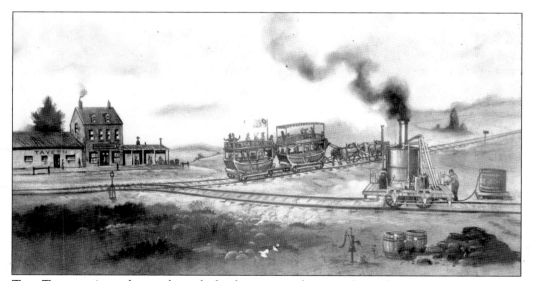

Tom Thumb. According to legend, the famous race between Peter Cooper's iron engine, the "Tom Thumb," and a horse-drawn carriage took place from Ellicott's Mills to Relay in August 1830. The horse won this race, but steam engines steadily improved, and the railroad became a vital link in the town's economy. (Courtesy of the Howard County Historical Society.)

CHARLES WERNER MEADS (1863–1926), c. 1888. Charles Meads was one of Ellicott City's barbers. His shop was next door to the Howard Hotel on Main Street. He was the son of Adam Meads, who served in the Spanish-American War and was discharged in 1898. (Courtesy of the Howard County Historical Society.)

MAUDE HOBSON MEADS, C. 1918. Maude Hobson Meads was the wife of Charles Werner Meads. Their son, Marion Meads Sr., changed the spelling of the family name to Meade. He had found various spellings of his family's name (Meades, Meade, Meads) among his ancestors and settled on the "Meade" spelling. (Courtesy of the Howard County Historical Society.)

CHARLES YATES'S FAMILY. Pictured from left to right are (first row) John Yates, Buck Yates, and T. S. Yates; (second row) Tiny Yates, Charles Yates, Ida Yates, and Trim Yates. (Courtesy of the Howard County Historical Society.)

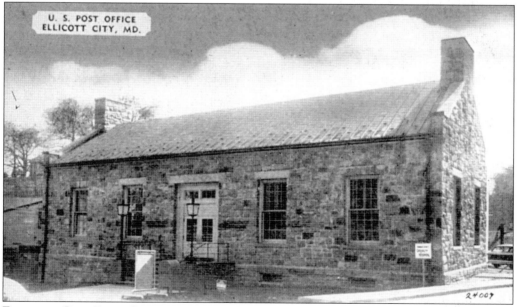

ELLICOTT CITY POST OFFICE. On December 7, 1940, the new Ellicott City Post Office was dedicated and opened for business. Michael Sullivan was the first postmaster of the new facility. Several old frame buildings were razed to make room for the new stone post office. Today, besides housing the Ellicott City Post Office, the lower level is home to the Howard County Department of Tourism and Historic Ellicott City, Inc. (Courtesy of William Hollifield.)

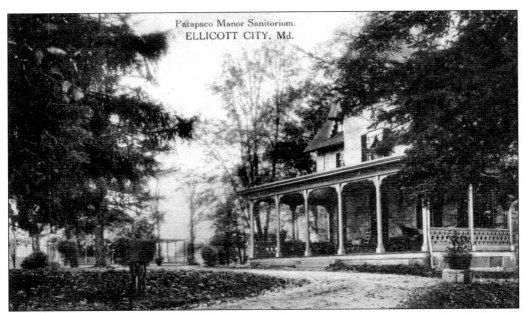

PATAPSCO MANOR SANATORIUM. The Patapsco Manor Sanatorium was founded in 1907. The mental health hospital had 10 to 12 patients on an estate of 56 acres. In 1939, Isaac Taylor purchased the sanatorium, then named the Howard County Sanitarium Company. Isaac was a successful Ellicott City optometrist and merchant who had built the Taylor's Furniture Store. In 1949, Irving J. Taylor, M.D., Isaac's son, became the medical director. In 1954, the hospital became Taylor Manor Hospital. This stone building still stands. (Courtesy of William Hollifield.)

PINEL CLINIC, TREATMENT ROOM AND OFFICE, C. 1941. In the 1940s, the Taylor Manor Hospital was renamed the Pinel Clinic after a French physician renowned for humane treatment of the mentally ill. Under Dr. Irving Taylor's direction, the clinic was the first hospital in the country to use Thorazine, the first neuroleptic, in 1953. (Courtesy of the Howard County Historical Society.)

PINEL CLINIC, DISTURBED WARD, C. 1941. In 1966, Dr. Irving Taylor started the first psychiatric hospital treatment program in Maryland specifically for adolescents. This was followed in the 1970s by the development of a dual-diagnosis program for emotionally ill substance abusers, called Group 9, and by a specialized young adult treatment program. (Courtesy of the Howard County Historical Society.)

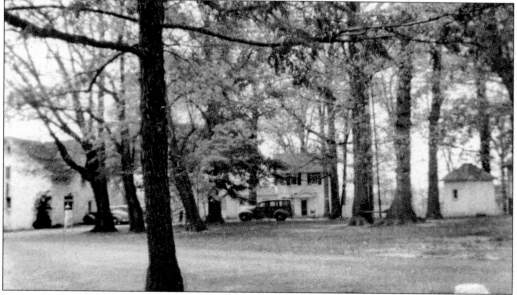

PINEL CLINIC, OCCUPATIONAL THERAPY SHOP, C. 1941. In May 2002, the Sheppard Pratt Health System acquired Taylor Manor Hospital. Dr. Bruce Taylor, the current director, said, "After much soul searching, our family of owners decided . . . to find an organization who could . . . assure the perpetuation of what we have built over the past 60 plus years. We have seen several other private psychiatric hospitals in our state succumb to bankruptcy over the past decade, and we were determined not to experience that fate." (Courtesy of the Howard County Historical Society.)

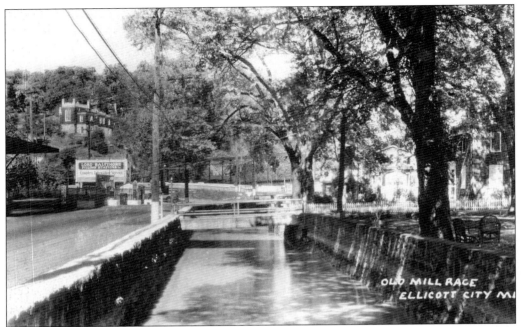

THE OLD MILLRACE. Sadly everything, with the exception of Angelo Cottage in the upper left-hand corner, is gone. The millrace was filled in to create parking space for the Patapsco Flour Mill. (Courtesy of William Hollifield.)

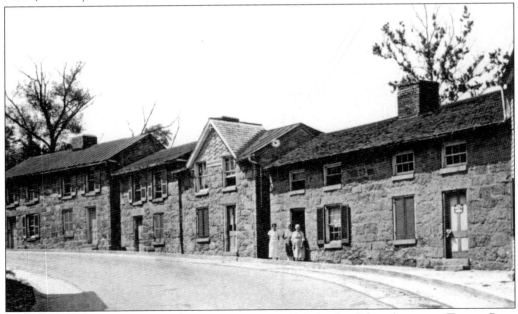

TONGUE ROW, 1936. This cluster of row homes on Old Columbia Pike is known as Tongue Row. In the 19th century, Mr. Tongue built the homes for mill hands. The odd name has lent itself to a more interesting tale of the origin of the name. It has been said that the houses were so close together that the women who inhabited the houses need only to raise their voices and "wag their tongues" to share the current gossip! (Courtesy of the Howard County Historical Society.)

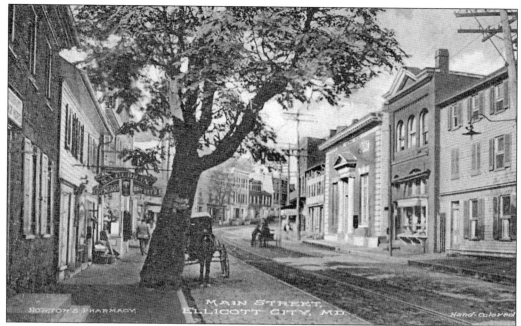

Main Street, Looking West. This postcard shows an early photographic view of Main Street looking west. (Courtesy of William Hollifield.)

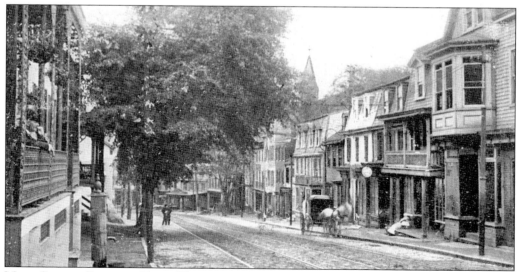

Main Street, Looking East. This postcard shows an early photographic view of Main Street, looking east. (Courtesy of William Hollifield.)

ACROSS AMERICA, PEOPLE ARE DISCOVERING SOMETHING WONDERFUL. *THEIR HERITAGE.*

Arcadia Publishing is the leading local history publisher in the United States. With more than 3,000 titles in print and hundreds of new titles released every year, Arcadia has extensive specialized experience chronicling the history of communities and celebrating America's hidden stories, bringing to life the people, places, and events from the past. To discover the history of other communities across the nation, please visit:

www.arcadiapublishing.com

Customized search tools allow you to find regional history books about the town where you grew up, the cities where your friends and family live, the town where your parents met, or even that retirement spot you've been dreaming about.